Long Beach
CHRONICLES

Long Beach
CHRONICLES

From Pioneers to the 1933 Earthquake

Tim Grobaty

Charleston London

THE
History
PRESS

Published by The History Press
Charleston, SC 29403
www.historypress.net

Images are from the *Press-Telegram Archives* unless otherwise noted.

First published 2012

Manufactured in the United States

ISBN 978.1.60949.548.0

Library of Congress Cataloging-in-Publication Data

Grobaty, Tim.
Long Beach chronicles : from pioneers to the 1933 earthquake / Tim Grobaty.
p. cm.
ISBN 978-1-60949-548-0
1. Long Beach (Calif.)--History. 2. Long Beach (Calif.)--Biography I. Title.
F869.L7G76 2012
979.4'93--dc23
2012007762

Contents

Contents

CONTENTS

Preface

The morgue is a beautiful place.

I'm not referring to the place where human corpses are stored, which isn't that grand a place at all, but the place where, at newspapers, history is stored, waiting to be resurrected.

In my thirty-five years at the *Press-Telegram*, I've spent hundreds of hours in the morgue—later, as journalism grew more polished and civilized (around the time we had to stop drinking and smoking in the newsroom), it was called the library—scrolling through microfilm, paging through historical volumes and, mostly, going through thousands of packages of clippings and photos.

It was all there, the entire and complete story of the city of Long Beach, from the public lives of mayors down to the kind of fish being caught off Pierpoint Landing. There were, before everything went digital, envelopes with my great-grandmother's name on them. My grandfather's, too. My parents' wedding announcement was there, and so was a front-page article about my mother's fatal car crash.

Many of the stories in the morgue were eyewitness accounts from people at the various sites of history, as well as from the reporters themselves who rushed down to the scenes, whether it was to witness the horror of the Empire Day disaster or the overwhelming sight of Henry Ford's new Long Beach plant churning out Model A automobiles.

This is where I did virtually all the research for hundreds of columns about Long Beach history over the past three decades. Reporters' accounts, which may have subsequently been straightened up and polished by historians who had the luxury of time, may have rushed the facts, typed up immediately after or even during the events. If the reporters made errors, those errors were often passed down through time, copied by later researchers. If they remain in this book, it's just as much my fault. I have tried, when "facts" clashed, to determine which set is the more accurate.

What follows in this book is nothing like a linear or chronological account of the city's history and far less a complete one. It spans, for the most part, the early history of the town, from 1888 to 1933. It hits some major points—the '33 quake, for instance—but mostly it's a collection of people, places and things that struck me as worth noting: the first phone directory, rules for high school students in the 1920s, laws regarding beachwear and what to plant in front of your yard.

Many of the pieces here are from a collection of fifty columns I wrote during Long Beach's centennial year, 1988; others are taken from an extraordinarily lengthy article about the *Press-Telegram*'s first one hundred years. And still others appeared over the last dozen or so years.

The people who have helped me the most during this span include some great editors: Harold Glicken and Rich Archbold, who are, happily, both still co-workers of mine at the *P-T*, as well as past editors Jim Robinson and Carolyn Ruskiewicz. Also, when I've needed outside researchers, Long Beach librarian, historian and author Claudine Burnett has been of great, and I'm sure accurate, help.

I am proud and pleased to dedicate this book to Agnes Carroll, Laura Elizabeth Grobaty and my wife, Jane, and our children, Raymond and Hannah.

Part I

The Newspapers and Their City

In 1997, the Press-Telegram *celebrated its 100ᵗʰ anniversary, a fairly hazy date that went back to the first days of the* Press, *as well as to the other papers with which today's* Press-Telegram *shares its heritage. The following is a brief (though long in terms of newspaper articles) intertwining of the city's early history and the newspapers that covered it.*

A copy of a photograph still survives, a century after it was taken, showing four men in front of what was called the Printing Office, a one-story building just a bit more elaborate than a shack that housed the *Long Beach Press*.

It was all the staff you needed to run a newspaper in a small town of two thousand. Among the men were J.H. Smith and John G. Palmer, the owners and publishers of the *Press*, which they fired up for the first time in 1897. The other pair, as forgotten as those first few scores of papers the sole machine issued forth, reported and delivered whatever news the seashore village was able to generate.

The road was dirt in front of the *Long Beach Press* building. From that spot, near the corner of First Street and Pine Avenue, our quartet of pioneer journalists could see and hear thundering surf pound the coast just a few hundred yards away. They could smell the crystalline perfume from the gloriously clean Pacific, feel the salt on their skin.

The sounds were of horses clopping, the traveling squeak of a carriage wheel on its axle, the intermittent clanging from a nearby blacksmith's shop, boys hollering, dogs barking.

It was, perhaps, a bigger deal getting a newspaper one hundred years ago. *Thwap!* You'd slap it, all rolled up and filled with moment and event, in your palm. You'd unfurl it at home, hunkered in your chair, or on the front steps or at the kitchen table. You'd read bits of it aloud to the family. Listen:

> *A ferocious school of sharks descended upon William Graves' nets last evening and made them unfit for further use by their partly successful attempt to get at the big catch of halibut and barracuda which were within.*

> *F.C. Paine, who has a small ranch at First and Falcon street, dug up a fifteen-pound sweet potato. This is the record for the sweet tubers in this vicinity, though Mr. Paine says he has plenty more as large if not larger than the one unearthed.*

> FOUND: *Bicycle, call at 245 E. First St. and pay for this ad.*

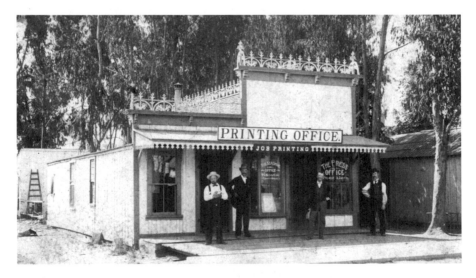

The *Long Beach Press*, with its staff of four, began serving the city of two thousand in 1897 out of its office near First Street and Pine Avenue.

A Newspaper War

There wasn't always a city's worth of news in the still-to-boom village as the century's turn came into view. But there was a city's worth of newspapers. When the *Press* first hit the streets in September 1897, it joined two other Long Beach papers already in existence.

The *Journal* began publication in January 1888, just days before Long Beach became a city. It was owned by Amos Bixby, brother of Long Beach pioneer Jotham Bixby, in partnership with H.W. Bessac. Bessac bailed out in the early going, and in 1890, Bixby sold the *Journal* to a schoolteacher from Oregon named Charles F. Drake (not to be confused, in case you were going to be, with the influential Long Beach promoter and developer Charles R. Drake). Drake changed the name of the paper to the *Breaker*, and he continued to publish weekly.

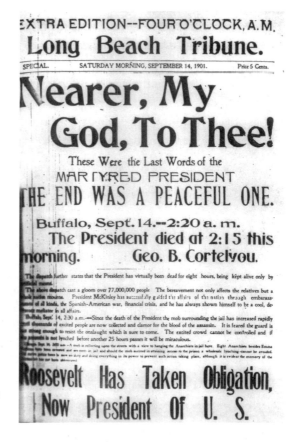

News of the assassination of President McKinley was brought to readers in the *Long Beach Tribune* in 1901.

After the *Breaker* had editorial run of the town for three years, the *Eye*, established by Robert M. Lynn, opened in October 1893, and in 1896, it became the city's first daily newspaper.

So, when the *Press* started running, there were three newspapers—a weekly, a daily and a semiweekly (the *Press* published on Tuesdays and Fridays)—serving the relatively quiet seaside town.

The *Press* struggled with the competition for only a month. In October, Palmer and Smith bought out the *Breaker* and the *Eye* and continued to publish twice a week as the *Press*, this still being the pre-hyphenated age; besides, who'd want to read something called the *Press-Eye-Breaker* at the kitchen table?

Still, the *Press* enjoyed its journalistic monopoly for only a brief while before another player came to town. T.W. Lincoln named his paper the *Tribune*, later calling it, a tad more regionally, the *Pacific Tribune*, and began publishing twice a week in May 1898. Sixteen months later, Lincoln, in order to save money for a big push, pared back to a weekly publication before purchasing new presses and launching the *Tribune* as a daily in December 1900.

By then, the pot was too rich for our original *Press* publishers, Smith and Palmer, who folded their hand in May 1899 and sold their enterprise to J.A. Miller. Shortly afterward, the *Press* was converted to a publicly held company, with the stock owned by forty major Long Beach businessmen. That influx of capital gave the *Press* enough money to convert to a daily publication (except Sundays) in November 1902.

CHRISTMAS 1902

Long Beach in 1902 was still a town trying to figure out which way to go. Though its population had grown to about five thousand and several businesses had sprung up around the city, it was still chiefly a beach resort—a nice place to visit for Los Angeles residents, who could ride the Pacific Electric line, which delivered its first batch of tourists to Long Beach on July 3 that year. The Long Beach Bathhouse, a cavernous pavilion on the beach at the foot of Pine Avenue, was the main draw, aside from the long beach itself.

The *Press*'s lead front-page story on December 26, 1902, headlined "How Long Beach Spent Christmas This Year," informed readers that

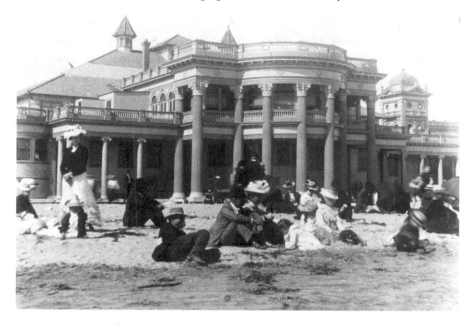

The Long Beach Bathhouse on the beach at the foot of Pine Avenue was the main tourism draw in the early days of the 1900s.

those who have been inclined to doubt the statement that Long Beach had grown to be a winter resort should have seen the crowd of visitors yesterday and the day before. It seemed as though the weather was bent on outdoing itself and the sky was as clear and the air as balmy as on the pleasantest June day...

Nothing happened to mar the harmony of the day and it is safe to assume that the great majority of the visitors went home with none but pleasant memories of the place.

Crime in 1902 was no stranger to the town, but it was the sort that wouldn't make the papers today. On December 10, 1902, though, a holdup attempt was the main news story of the day. "R.E. Tiller was the victim of a bold hold-up attempt at an early hour last evening," the *Press* reported.

He was on his way down town...when, near the corner of 6th and American, he was stopped by two men who wanted him to hold up his hands. As is usually the case he lost no time in complying with so

reasonable a request, but at the same time assured his newly made friends that he didn't have a cent. When they had assured themselves of the truth of that statement…he was told to "git for home and git fast and not look around." He went and his speed was fully up to requirement.

The *Press* further noted that "a party of rather hard-looking visitors was suspected of the crime."

It was typical during the early years of this century for newspapers to plaster ads on about half of the front page, and these ads tell as much about the time as the stories that accompanied them. If you ever get a chance to travel back in time to 1902, bring your wallet. Realtor George H. Blount (with offices at 226 Pine) was peddling lots in the "Fourth Street Sub-division—near celebrated Carroll Tract—for $150 to $200 per lot ($25 to $50 cash)."

If you could part with $2,250, one of the city's early leaders, W.W. Lowe, would sell you a five-acre spread a half mile out of town, "with a new five-room house, land set to alfalfa and barley, one horse, wagon and harness, one Jersey cow, all farming tools and 75 laying hens."

For those low on disposable cash, the Long Beach Methodist Resort Association would let you camp in its grove near a stretch of the strand for three dollars per month, unless you wanted to live like a lord, in which case ten dollars a month would get you a cottage tent containing "bedstead and springs, lamp, table, chairs, wash stand and pitcher."

A host of dry goods was available at the New York Racket, at Second Street and Pine Avenue, where a nickel would buy a mouse trap, a lamp shade, a sponge, a pie plate, twenty-four clothespins, a bottle of Carter's black ink or toilet paper (round or square). Men's socks were a dime, buggy whips were $0.15 to $0.45, ladies' hose ran from a dime to a quarter and Mrs. Pott's sad irons were $1.20 for the set.

The year 1906 brought Long Beach's first major disaster when, on November 9 at 9:45 a.m., portions of the fifth and sixth floors collapsed during construction of what would later become the palatial Hotel Virginia, killing ten workmen and injuring twenty-five.

The *Press* rushed out an extra edition within hours of the accident, and you can almost see the reporter scribbling madly (there were no bylines in the *Press* at the time) as he took an account from an injured worker, a carpenter named Ira Zee:

I had just finished nailing a joist and several laborers near me were carrying a heavy timber to the west end of the building. It seems that just as they let the beam fall, with unnecessary violence, the building beneath me I was on the fourth floor trembled...

As I fell, the air around me was filled with piercing shrieks of men buffeted and pinioned by the timbers. Huge blocks of concrete missed me by a hair's breadth, it seemed, and I was struck by several smaller pieces, then came a blank for a time, when I felt men assisting me to the road.

Also on the tragic scene that morning were many of the moneyed men who were bankrolling the construction, including one of Long Beach's most influential early promoters, Charles Rivers Drake, who announced that, while saddened over the loss of life, "the work of reconstruction of the hotel will commence tomorrow morning. Extraordinary care shall be taken in the future to prevent such accidents." Drake further averred, "My faith in reinforced concrete is unshaken."

The hotel was indeed built, and the opulent $1.25 million shoreside palace became the center of Long Beach's tourist and social scene from its opening in March 1908 to its failure to survive the Depression in 1932. It was torn down in 1933.

In an effort to find a niche for itself in the growing Long Beach market, in 1907 the *Pacific Tribune* switched to a morning paper. All three papers had been publishing on Mondays through Saturdays, but the *Trib* opted to go dark on Monday and put out a Sunday edition—the town's first— instead. Still, it couldn't make a go of it, and the *Tribune* was folded into the *Press* on September 1, 1907.

THE PRISK YEARS

In 1910, the *Press* was acquired by one of Long Beach's most colorful and successful publishers, William F. Prisk, in partnership with his brother Charles and A.J. Hosking.

Prisk was a lifetime newsman, starting out as a newsboy in Northern California with the *Grass Valley Tidings* when he was ten years old. By the time he graduated from high school, he had borrowed $250 from a friend in order to start up a competing paper, the *Grass Valley Evening Tribune,*

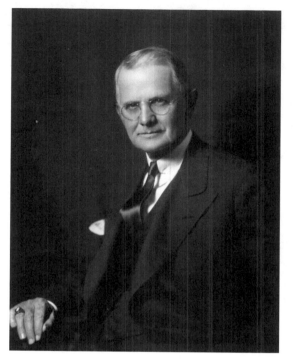

William F. Prisk is the father of Long Beach newspapering. He bought the *Press* in 1910 and was its publisher through several mergers and acquisitions for more than forty years.

for which he served as typesetter, reporter and business manager. After selling out his interest in the paper in 1891, Prisk's jobs included reporting for papers in San Francisco and Sacramento, as well as a term in the state senate.

By 1906, Prisk and his younger brother Charles decided to get into newspapering in Southern California, purchasing the *Pasadena Star* in that year and merging it with the *News* ten years later to create the *Star-News*.

They next set their sights on Long Beach and bought the *Press*, with its circulation of 3,000, in 1910. When they sold the paper forty-two years later to the Ridder family, its circulation was in excess of 100,000.

In addition to the usual attempts to influence policy on the local and national levels through his editorial pages, Prisk also printed a daily column peppered with one- or two-sentence bon mots and musings:

> *Political conditions at Pekin are a Chinese puzzle.*
> *Noise never nominated a man for the Presidency.*
> *Mother deserves whatever she wants for a Christmas present.*
> *One Congress composed of deaf mutes would be a refreshing novelty.*
> *Young man, before taking unto yourself that June bride, make sure that you will be equal to the task of profanelessly buttoning her up the back after the honeymoon is over.*

FASTEST-GROWING CITY

Long Beach was beginning to bustle in earnest when Prisk took over the *Press*. From its 1900 population of 2,252, it had grown to a city of 17,809 in the following decade, a pace unmatched by any other city in the 1910 U.S. census.

Work on the harbor was almost completed, and scores of businesses bustled around the town. On December 3, the new Craig Shipyard launched a 266-foot steel steamship, the *General Thomas Hubbard*, with the *Press* reporting that "more than 10,000 persons witnessed the launching, the north bank of the channel being black with spectators for a distance of more than half a mile" to watch the launching of the first steel vessel south of San Francisco.

Two weeks later came the dedication of Polytechnic High School, "one of the Most Impressive Educational Events in History of Great Southwest," according to the *Press*'s front-page headline. It, too, drew a huge crowd for the ceremony, held, as was reported by the paper's hyper-observant reporter,

> *in the open air beneath a cloudless sky, with mountains rising in their majestic grandeur in the distance, each rugged line softened by robes of hazy purple mist, while the shimmering blue waters of the mighty Pacific gleamed under the rays of an incomparable California mid-Winter sun.*

The following year brought another big boost to the city with the arrival on June 23, 1911, of the steam schooner *Santa Barbara* to the new Long Beach Harbor with a consignment of lumber for the Long Beach Improvement Company.

"While this is not the first cargo to arrive and be unloaded on the docks," the *Press* reported, "the fact that the vessel was one of the largest that has ever entered the harbor and the consignment the most important that has ever been sent here" made the ship's arrival at the municipal docks "an event of supreme importance to Long Beach and Southern California."

Having taken care of the sea, Long Beach turned its gaze toward the heavens, and all eyes were on Long Beach as local hero Calbraith Perry Rodgers became the first aviator to complete a coast-to-coast U.S. flight.

In 1911, Calbraith Perry Rodgers became the first aviator to complete a coast-to-coast U.S. flight in a journey that took three months, sixty-eight takeoffs and fifteen crashes. He landed off the strand in Long Beach on December 10, "in front of a frantic multitude of 50,000," according to the *Press*.

He took off from Sheepshead Bay in Long Island on September 19, 1911, and landed almost three months, sixty-eight takeoffs and fifteen crashes later on the strand in Long Beach on December 10, "in front of a frantic multitude of 50,000," according to the *Press*.

"Sunday, December 10, 1911, went down as an epochal date in the annals of aviation," trumpeted the *Press* report.

> *Sailing almost due southward over Signal Hill and out across Devil's Gate (near today's Belmont Pier) to an elevation of 1,500 feet over the ocean, he turned westward, sped over the Virginia Hotel and a portion of the business district of the city, sailed out to sea again and landed on the sand at exactly 4 o'clock.*

The importance of the transcontinental flight was not lost on the *Press*, which offered its opinion on the future of aviation:

> *While it is not yet fully demonstrated that the airship is perfected as a means of transportation, it has proven beyond a doubt that it is of inestimable*

value…and the prevailing opinion is that within a comparatively few years some ingenuous Yankee will so perfect the type that it will be just as safe and far more speedy than the transcontinental trains.

SMALL-TOWN NEWS

Still, in those early days of the twentieth century, in between matters of great import, the bulk of the *Press* remained taken up with the daily doings of a small town, however burgeoning:

> *An old man strolling along the Pike yesterday afternoon found a small purse containing 20 cents in coins and a key, which he turned over to Policeman Brown, who left it at the police station.*

> *Mrs. C.A. Simpson, of 515 Ohio St., has petitioned the police to put a stop to the chicken nuisance in that neighborhood. It is said that chickens roam about the streets and lawns with all the abandon of absolute ownership.*

And this, on Prisk's editorial page in the May 23, 1911 edition of the *Press*, on the eve of Empire Day, a celebration of music, recital and oration that was to be held in the Municipal Auditorium to celebrate the heritage and culture of Great Britain: "No more desirable, no more agreeable or welcome gathering could come here than will be the throngs of tomorrow," wrote the editor. "It will be a stirring day for every son and daughter of Britain in attendance, as well as their American-born cousins."

It would be nothing of the sort.

THE EMPIRE DAY DISASTER

Empire Day fell on a spring Saturday, May 24. Hundreds of gleeful Britons, Canadians and Anglophiles stood on the Pine Avenue Pier's approach to the old wooden auditorium, waiting for the doors to be opened. A band struck up glorious strains of martial music in the distance, and the impatient partiers began to stomp in time.

Because of the weight and the stomping of the merrymakers, the upper section of the double-deck Pine Avenue Pier crashed through to the lower deck, also crowded with visitors.

Press reporter John Meteer wrote, just a few hours later, "Snapping the timbers of the lower deck as matches, the awful tragic homogeneity of splintering planking and shrieking humanity went down to the sand, just a few feet distant from the sand, at low ebb."

Some 350 persons were involved in the collapse of the pier. Fifty died; 174 were injured.

Even as bodies still lay strewn on the beach, an editorial in the *Press* urged the citizenry to soldier on: "As a ship stricken but not engulfed, Long Beach shall rise from the calamitous trough of this sea of despond to ride swifter upon her way to a greater haven."

The World Goes to War

On April 6, 1917, the United States entered what would later be called World War I, and Long Beachers swiftly entered the fray. The *Press* opened its columns to the war effort, scattering ads throughout the paper exhorting people to give to the war effort ("Treat 'em rough buy more bonds") and devoting its front pages to the urgent missives that poured in from news agencies in France: "Yanks Smash Four Miles of German Defenses," "Brave French Camping on St. Quentin Doorstep," "Hun Diabolism Is Past Belief."

The *Press* carried a daily feature, "Uncle Sam's Boys," that profiled different Long Beach servicemen in each installment. The paper also published each day a complete casualty list from the U.S. Department of War.

Even the ads took on a martial and patriotic air. A clothing store on Pine Avenue ran an ad showing a dapper man next to the copy: "This man is 'doing his bit' by keeping the 'pot boiling' at home. He's making every dollar do its full duty; looking twice at what he spends and twice at what he buys; and he buys Kuppenheimer Clothes."

Long Beach, still just a city of fifty thousand, sent two thousand young men to fight the war in Europe, many of whom had already joined the Canadian, English and French forces before the United States entered the conflict.

Long Beach sent its share of young men and women to do battle in World War I. Seventy-seven Long Beach men died. Thirty-three were killed in action, six died of wounds, fourteen died of disease, four were killed in airplane accidents and twenty died from other accidents.

The first Long Beach boy to die in battle was Arthur L. Peterson, who was killed on a battlefield in France. Long Beach's American Legion Post on West Broadway remains named for Peterson.

By the time the war ended on November 11, 1918, Long Beach had lost seventy-seven men in the war; thirty-three were killed in action, six died of wounds, fourteen died of disease, four were killed in airplane accidents and twenty died from other accidents.

Nature, though, easily outstripped the war's capacity for catastrophe in 1918, bringing an influenza epidemic of stunning proportions to the world. Some twenty million people died from the so-called Spanish flu, including 540,000 in the United States.

Long Beach wasn't stricken to the extent that many American cities were, but the city was in the grips of the panic in October 1918, when five deaths were reported in as many days, causing the city council to

close virtually all public gathering places for several days. These included, according to the *Press*, "the public and private schools in Long Beach, churches, moving picture shows, dancing pavilions, bathing plunges, lodge meetings and public gatherings of any and every kind."

THE BOOM RESUMES

As the 1920s came roaring into Long Beach, the city had recovered from the war and the plague and was concentrating on booming once again. The Pike was crowded with strolling couples, the men, to a man, dark-suited and hatted and the women wearing ankle-length dresses and, frequently, bonnets. Breakers still crashed along the pilings of the double-decked Pine Avenue Pier, as well as the Belmont Pier farther to the east that had been dedicated on Christmas Day 1915.

The canals of Naples had been dredged, and work was beginning on homes there. Belmont Shore, too, was in the building process, and walkers down that area's dirt road called Second Street had to be alert for both Model T Fords and horses.

Streetcars zipped up and down Pine Avenue, bringing customers to the Army-Navy Department Store, the Kress 5-10-25-Cent Store, Sam Abrams "Tailor of Merit," the Queen City Market, the National Dollar Store ("Nothing Over One Dollar"—what a concept) and, at least some things haven't changed, the Farmers & Merchants Bank.

Long Beach was still growing rapidly. The 1920 census showed that the town had grown from 17,809 in 1910 to 55,593 in 1920, a gain of 212.2 percent, making Long Beach again the fastest-growing city in America.

It was no longer simply a tourist spot, for its industries were also thriving. A *Long Beach Facts & Figures* pamphlet, issued by the *Press* in October 1920, listed 143 industries, which employed 5,576 workers in the town. The companies included two shipbuilding plants, six fish-packing companies, five furniture factories, two toy factories, a dozen auto body builders, a cigar factory, a hat factory, three bookbinding plants, two pickle factories, three rugworks and two mattress companies.

When it seemed things couldn't get any better, this headline gushed from the front page of the May 24, 1921 edition of the *Press*: "Strike Oil in Signal Hill Well—Shell Company Discovery Arouses City."

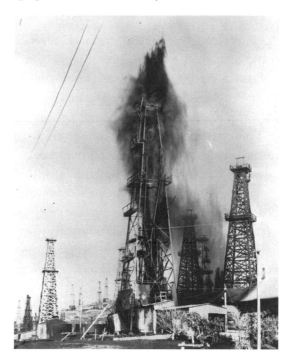

In 1921, oil was struck on Signal Hill. According to the *Press*, some three thousand Long Beachers traveled out to witness the gusher.

In the story, a Shell official said, "We do not know how much oil there is in the well…Of one thing we are sure, however, and that is that we have oil on Signal Hill."

Word of the strike traveled fast. On the day of the oil's discovery, some three thousand people, the paper reported, had visited the well. Within weeks, derricks sprouted on the hill like mushrooms. Anyone with a dime could get into the oil game, as announced by an ad in the *Press* three days after the Shell well paid off. Offering shares in oil stock at a dime per share, the ad trumpeted, "Our derrick is completed SPEED has established a record in its building. Trucks are now delivering our machinery…IN JUST A FEW DAYS NOW our drill starts down for OIL."

Extra! Extra!

The boom years led, too, to a brief explosion of newspapers in Long Beach. Los Angeles publisher F.W. Kellogg opened the *Long Beach News* on March 5, 1923; it was the first paper in town to carry stories from the

Associated Press. And less than a month later, on April 1, 1923, came the rising of the *Long Beach Sun*.

By the end of the year, however, the *News* had been folded into the *Daily Telegram*. So now the town had two afternoon papers, the *Press* and the *Daily Telegram*, and the morning *Sun*.

Then, after competing headline-to-headline with each other for twenty years, the time of Long Beach's biggest and most astounding growth, the *Long Beach Daily Telegram* merged with the *Long Beach Press* on September 1, 1924, to become the *Long Beach Press-Telegram*, with *Press* editor and general manager William F. Prisk serving as president, editor and general manager and the *Daily Telegram*'s co-owner and editor (and founder's widow) Belle McCord Roberts as vice-president.

In a front-page story in the final edition of the *Press* on August 31, the consolidation of Long Beach's two afternoon dailies would result in "greater service to the public, a better newspaper for the promotion of Long Beach interests, more power for civic progress and the elimination of unnecessary and costly duplication." There was no reason, the merged owners reasoned, for two papers "to be doing the same work twice."

"The *Press-Telegram* has no special hobbies to promote," its publishers assured readers. Even so, the publishers unabashedly proclaimed that in matters of national politics,

> the *Press-Telegram will be Republican, conforming to the majority views and affiliations of its publishers, who believe that the Republican party stands for sanity and progress...*
>
> *The* Press-Telegram, *however, will not be blindly partisan, and will reserve the right to independent expression, as conditions justify and as the general welfare demands.*

The *P-T*'s goals increased to even loftier heights in a front-page editorial the following day, under the new *Press-Telegram* banner. The paper would, it announced, "endeavor, without slackening of intention, and without deviation from the lofty principles which it proclaims, to impress upon the universal mind the best there is in Western civilization." And for just a nickel a copy.

The new *Press-Telegram* began its reign at offices on 422 Pine Avenue while waiting to move into a new building, then under construction, down

This stucco house (now gone) on the grounds of Long Beach Airport was the home of airport manager William Putnam and his wife. When Charles Lindbergh landed at the airport in 1929, he enjoyed a dinner and a rest there, away from the crowds, before heading off to the Breakers Hotel.

the street at Pine and Sixth Street. It also maintained a business office during that period at the *Daily Telegram* building on 333 Locust Avenue.

Also in 1924, the Long Beach Municipal Airport was established, way out in the sticks. And the airport had an esteemed guest a few years later when Charles Lindbergh, almost one year to the day after his transatlantic flight from New York to Paris, made an unexpected landing at the Municipal Airport at 3 o'clock in the morning on May 31, 1928. Forced to make a landing in Southern California from a flight that began in Arizona, en route to San Francisco, Lindy told reporters that he could spot Long Beach by the huge electric sign atop the Breakers, which prompted local civic leaders to hastily adopt a new slogan: "Long Beach: Where Lindbergh Saw the Light."

After his early morning landing and a breakfast at the airport manager's house on the airport grounds, the aviation hero hit the hay

at the Breakers downtown. Word of his arrival had swept through town, however, and it seems few people could withstand the temptation to get a glimpse of their visitor.

The *Press-Telegram* reported that

> *8 o'clock found the lobby of the Breakers Hotel full of people waiting to see Lindbergh. Nine o'clock found it jammed and the overflow spilling over onto the lawn. By 10 o'clock the crowds in the lobby, the corridors and the elevators had become denser and denser. By noon, restless at the delay in the appearance of* [Lindbergh], *the crowd was kept quiet only by police control. The police provided the flyer with an escort back to the airport later in the afternoon, and a crowd of thousands showed up to watch him take off.*

The Long Beach area closed the 1920s with a spectacular thirty-nine-day Pacific Southwest Exposition, a sort of scaled-down world's fair held on a previously barren peninsula that jutted out into the harbor. Eleven western states and thirty-nine countries from Asia, Australia, Europe, Latin America and South America were represented in buildings and tents on the site to show off their latest offerings in commerce, technology and culture.

And while hundreds of thousands of visitors had a jolly good time during the run of the expo, its chief purpose was to thrust Long Beach into the world of international trade. The ambitious little town was no longer satisfied with being a cozy weekend getaway for Los Angeles visitors or a therapeutic and final haven for retirees from the Midwest.

As the *Press-Telegram* noted in its front-page editorial on the eve of the event's opening:

> *The holding of the exposition at the time when Long Beach is starting on the program for completion of the great harbor project is no mere coincidence…A primary object in having this exposition and "inviting the world" to see it was to signalize the realization of Long Beach's dream to become a port of great commerce.*

THE CYCLONE RACER

The 1930s showed that dream of great commerce continuing at a breathtaking pace. The population had again skyrocketed, from the 1920s, at 55,593, to 142,032. City leaders saw no reason to believe that the town wouldn't reach half a million by 1950. The Pike was still peaking down on Seaside Way. The amusement park would see its third and final great roller coaster, the Cyclone Racer, erected in 1930, following its two extinct thrillers: the original coaster, which ran from 1907 through 1914, and the Jackrabbit Racer, which rolled from 1915 to 1929.

The godfather of modern American commerce, Henry Ford, came to Long Beach in April 1930 for the opening of a new Ford plant in the city's harbor district on a forty-acre site purchased by Ford from Union Pacific.

The Ford plant immediately hired about two thousand Long Beach workers to assist in the assembly of cars—some three hundred autos daily—for the southwestern United States.

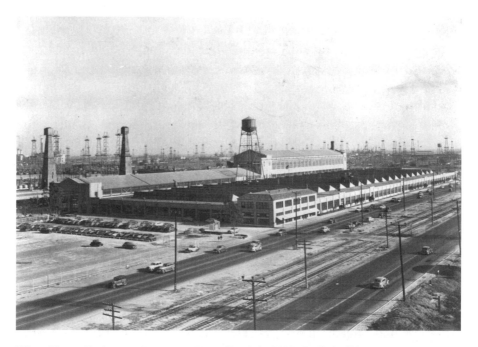

When Henry Ford opened a plant in Long Beach in 1930, the *Press-Telegram* assured the company that "support will be forthcoming cheerfully and in good measure."

Again, the *Press-Telegram*, in a front-page editorial, rejoiced in the plant opening, which further fulfilled the city's hankerings to be a world commerce center, and the paper assured Ford that "in whatever way Long Beach can co-operate to advance the interests of its industrial units, this support will be forthcoming cheerfully and in good measure."

More progress came hot on the heels of the Ford plant opening. The opening of a Proctor & Gamble plant in 1931 furthered the city's commercial and industrial ambitions, as did Herbert Hoover's signing, on July 30, 1930, of an appropriation for a 12,500-foot breakwater expansion. But Long Beach hadn't forgotten its pleasurable aspects, either, and the glorious Rainbow Pier, long on the drawing board, was completed in 1931. And in 1932, for the Los Angeles Olympics, the rowing events were held in Long Beach's Marine Stadium (the U.S. rowers won), bringing the town to the attention of the nation once again.

WHEN THE EARTH MOVED

People in Long Beach at the time must have wondered what could go wrong. It was a city—no longer could it be called merely a town—blessed in every way.

Then, toward dusk on March 10, 1933, in the time it will take you to read from this word to this one, Long Beach began falling apart. Violently.

The earthquake that nearly ruined the city was no great shake in the annals of seismography. The Richter scale had not yet been developed, but scientists later put the quake at somewhere between 6.0 and 6.3. But the relevant and tragic numbers were these: 51 dead in Long Beach; 40 in other cities, including 6 in Huntington Park, 4 in San Pedro, 3 in Artesia and 3 in Bellflower. Injuries totaled 4,883, including 536 of them in Long Beach.

Damages in Long Beach alone were eventually set at about $50 million, and this at a time when $1 million could buy more than a three-bedroom home with an ocean view.

The town, still proudly proclaiming itself the fastest-growing city in America, had built itself too quickly and too shabbily. Of the 31,485 homes in Long Beach, 21,000 were damaged.

At the forefront of reasons to gives thanks in the wake of the quake was the fact that school was out for the day. Of the city's twenty-six schools, twenty-three were badly damaged and several completely ruined.

The city was caught completely off guard. An earthquake had never been experienced here, and though everyone knew well of the disaster of San Francisco's 1906 quake and fires, Long Beach had thought itself immune. It was simply not built well, and the '33 quake took advantage of every structural weakness it could find, especially in homes, schools and churches, many of which were built of unreinforced masonry. In fact, most of the fatalities occurred when falling walls, cornices and parapets struck people fleeing from buildings.

THE NEW JOURNALISM

A level of even-toned professionalism had come to the city's newspapers by 1933. Grim, straight-faced coverage had replaced the operatic reportage that marked the papers' Empire Day disaster two decades earlier.

Those reading the newspaper outside tents in the park or in line at Red Cross soup kitchens or amid the rubble of their own homes and

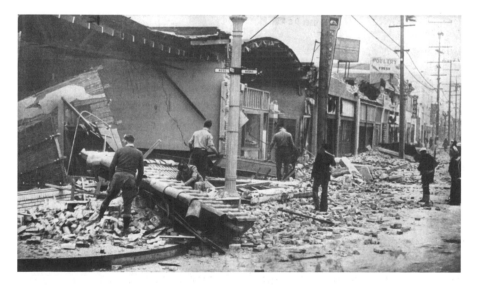

Navy personnel and civilian volunteers examine the rubble at Rose Avenue and Anaheim Street following the March 10, 1933 Long Beach Earthquake.

businesses did not need the *Press* to tell them that an earthquake had hit. Instead, the paper lunged right into a litany of the deceased.

"Known dead in Long Beach at 10 o'clock today as the result of last night's earthquake," began the paper's main news story in its March 11, 1933 edition. Elsewhere on the front page were stories about relief services that many private businesses were offering to quake victims. There were also notices of gas and other utilities being cut off for the city until repairs could be made. And the front-page editorial resonated with the same hope that it had offered following the Empire Day tragedy. Beneath the headline "A Greater Long Beach Will Rise," the editorial addressed the city's immediate task:

> *First, relief for the injured and destitute. Then clearing away the debris. Next, reconstruction.*
>
> *In all of these channels of activity, there will be unity of spirit and effort. Long Beach has proved, on other occasions, which as necessity arises there can be a pull-together spirit that will brook no obstacles, nor hesitate when discouragements appear. In this greatest of all tests of community character that has ever faced this city, there will be no holding back. Rather will there be 150,000 loyal residents, each ready to do his and her part to the fullest.*

The pep talk paid off. The following day's edition of the *Press* included this small item:

> *Three Long Beach men, well-known to police as "higher-ups" in connection with alleged liquor-ring violations, walked into police headquarters shortly after midnight, each carrying two five-gallon cans which they said contained alcohol.*
>
> *"Here, boys," said one to the officer in charge. "We have thirty gallons of pure alcy. Use it for medicinal purposes."*
>
> *The liquor was set on the floor and the men walked out.*
>
> *Police said they might turn it over to city health department for a test to determine its quality.*
>
> *No arrests were made.*

ANOTHER MERGER

Shortly before the quake, Long Beach's morning newspaper, the *Sun*, was sold to the *Press-Telegram*, and its equipment was moved into the *P-T*'s building on Sixth and Pine just in time for the earthquake, which shook the building with enough force to send a water tank crashing from the building's roof down to its basement. The vacant Sun Building, three blocks to the south on Pine, was undamaged and served as the city's temporary public library while the library building was being repaired.

The names remained the same, however, after Prisk acquired the *Sun*. The *P-T* came out in the afternoon and the *Sun* in the morning, with the Sunday paper being called the *Press-Telegram and Sun*.

On August 30, 1933, with the Press-Telegram/Sun Building thoroughly repaired and enlarged, and being the only journalistic game in town, the papers threw open their doors for a three-hour open house and tour to explain the workings of the papers and a demonstration of the equipment.

An astounding twelve thousand people visited the four-story building. At times, the influx of visitors stretched for a block down Pine. Ushers moved the thousands of people through the plant, explaining each detail of operation.

The Municipal Band showed up at the newspaper offices to perform an informal serenade, and a marimba band and orchestra performed throughout the open house. Inside, the entire building was decorated with flowers and plants. "Seldom in the history of this city has such a brilliant display of floral beauty been seen upon a single occasion," reported the *Press*.

The paper also took the occasion to document its endeavors. In the special open-house edition, numerous stories were given over to describing the workings of the papers.

"Every phase of human activity which might prove of interest or value to readers of the *Press-Telegram* is unearthed by the more than forty reporters and editors of the news room," the paper boasted. "They delve into every nook of municipal affairs, every cranny of local government or justice, and every corner of civic and social life of the community and its surrounding towns in their search for news."

The *Press-Telegram* had grown from when the *Press* offices sat next to the *Telegram* offices on First Street, each with a staff of fewer than a half

dozen reporters. Now, the *Press-Telegram*'s suburban department was spreading out to cover some fifty-five towns in its vicinity, from the as yet unincorporated areas of Bellflower and Downey all the way down south to San Clemente and as far up the coast as Manhattan Beach. In its open house edition, the paper offered such facts as:

> *If the square miles covered by reporters of the* Press-Telegram *suburban department were laid end to end they would make a road a mile wide from Long Beach to within a few miles of Kansas City, Mo., and the reporters cover this territory every day.*

> *Eight full-time reporters drive automobiles more than 2,000 miles each per month…to gather news for the suburban edition of the* Press-Telegram. *This mileage more than girdles the earth by the middle of the second month* [each year].

In just a couple years after the quake, Long Beach had become, as the editorial presaged, a stronger city, better built and running headlong into the future.

Part II

The Columns

DULCE ET DECORUM EST

We couldn't keep the headstone clear of the mud and rain.

It was cold, as cold as it ever gets here, and the leafless trees provided no more shelter from the glancing rain than an umbrella that's lost its fabric, leaving only exposed ribs.

We were underdressed and undershod. My daughter wore a now-drenched hoodie and jeans; I was sloshing about in a pair of loafers that were never going to be usable again after this. And the two of us were lost in a sea of dead people.

The site was the Long Beach Municipal Cemetery, right next to the older Sunnyside Cemetery on Willow Street. My daughter Hannah was doing a high school project on World War I, and she decided to center her assignment on people in Long Beach who served in the Great War, as it was called. It certainly wasn't called World War I at the time because it was to have been the War to End All Wars. A war as horrific as the Great War doesn't dare imagine a sequel.

Hannah wondered if there were any veterans of the war alive in Long Beach whom we could talk to. I explained the math and the actuaries. The only vets from the First World War we were going to commune with were here at Long Beach Municipal and other places much like it.

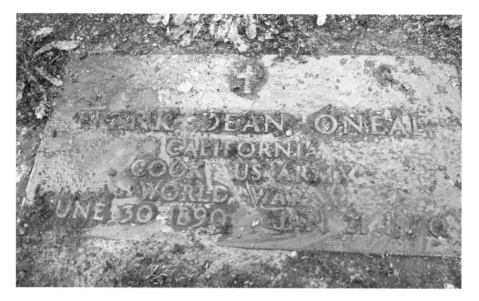

Rain and mud masked the grave marker of Long Beach World War I veteran Frank O'Neal, a 1916 Poly High graduate. *Hannah Grobaty.*

We found out a couple of days later that one U.S. veteran of World War I, though not a local boy, had still been alive, though we only found out on Sunday, when we learned that West Virginian Frank Buckles, who had enlisted at age 16 and was the last living doughboy and grappler with the actuaries, had died at 110.

The grave marker we had been trying to keep clean enough for a photograph, without much success—we lacked any tools, where a stiff broom or even a sturdy rag might've done the trick—stood vigil over the body of Frank Dean O'Neal, born in June 1890 and died in January 1970.

In *Long Beach in the World War*, a book compiled by the American Legion in Long Beach in 1921, we discovered that the young O'Neal was born in Lyndon, Kansas; enlisted in B Company, 316th Ammunition Train, 91st Division; was sent overseas on July 12, 1918; and was stationed in France at Cherbourg, St. Ammont (probably Saint-Amant), Billom and Saint-Nazaire. He was discharged on May 13. He married Grace Hess on September 3, 1917.

In the *Press-Telegram* many Septembers later, a small item noted that Frank and Grace celebrated their fiftieth wedding anniversary. Grace,

the article tells us, was a 1916 Poly High graduate. Frank, we learned, "is a well-known California highway and trucking contractor."

Frank Dean O'Neal's grave marker, in its necessary economy of words, distills the deceased's achievements as:

Cook. US Army
World War I

I used my hands and battered loafers to scrape enough soaked earth away to read even that much. Hannah took some pictures of the marker, and we marched off to find more.

Almost everything's ineffable at a quiet cemetery like Long Beach Municipal—the sadness, the sacredness, the serenity. And my daughter and I were the only two people on the living side of the lawn, bending against the wind and rain. Oh, the discomfort! Could anyone have had it worse than us at this moment?

I remembered the gist of a letter written in Bourges, France, during Thanksgiving 1918, from a young corporal, Charlie Swift, to his father back in Akron, Iowa.

It's a long letter, and I only know of it because Corporal Swift writes of meeting Hannah's great-grandfather, also of Akron, Iowa, on the streets of Bourges. Swift had been fighting on the front lines for seven months when a shoulder wound sent him to a hospital in Bourges.

"Yes, father, I think I have done my little bit in this old war," wrote Swift.

> *I have been in some of the worst battles that have been fought. I was on five different fronts and have witnessed some of the worst sights that could be seen...It's pretty hard to see your pals that you have eaten with and slept with get knocked off.*
>
> *I think it has done me good. I don't think I will ever have reasons to crab again at anything that goes wrong...*

With that thought, I stopped crabbing. I held my daughter's hand and soldiered on. It's no problem at all. In fact, it felt like an honor.

And anyway, a little rain never killed anyone.

"HE WAS KILLED GOING FORWARD"

On November 11, 1918, the War to End All Wars came to an end. And because other wars and time have done much to erase the memories of that horror, it has been a long time since we've paused to remember the local heroes who gave their lives on the field of battle in that First World War.

The following men were the soldiers and marines from Long Beach who died in action in the Great War:

Bernard Ace, twenty-two, joined the Canadian army and was killed in action on the Western Front on August 15, 1916.

Stepan Andrijasevich, a Serb, volunteered for the U.S. Army. His naturalization papers were processed after his induction. He was killed in action on September 27, 1918.

Eugene Clarence Binger, twenty-three, was killed when Germans attacked his company during training in France on September 14, 1918.

Ernest Henry Burns, twenty-five, was killed in action in France on September 15, 1918.

John H. Carter was killed in the Meuse-Argonne Offensive.

Vernon Edmund Challis, twenty-three, was born in New Zealand and severely wounded at Gallipoli. He returned to service and was killed in the Somme Offensive.

Harry William Elliot, twenty-five, enlisted in the U.S. Marines in 1917 and was killed in action on June 6, 1918, in the fierce fighting that preceded the final turning back of the German drive on Paris.

Ira Evans was killed overseas on Decoration Day, May 30, 1918.

Albert Edward Forker, twenty-three, was killed in the Meuse-Argonne Offensive on September 28, 1918, and buried in the American Cemetery at Romagne.

Joseph Knight Glossbrenner, twenty-six, enlisted in the U.S. Marines with his brother Floyd in May 1917. Joseph was killed in action on October 6, 1918. Floyd survived and was in the trenches in the advance line at the time of the signing of the Armistice.

Frank Lambert participated in the St. Mihiel and Meuse-Argonne Offensives. He was killed in action on October 3, 1918.

Irwin Earl Lower enlisted in April 1917, immediately after America entered the war. He served as sergeant on the Western Front throughout

the severe fighting of the summer of 1918. He was killed in action on October 26, 1918.

Herman Leonard Olson, twenty-one, saw action in St. Eloy, Vimy, Arras, Cambrai, Douai, Carency and Lens before being killed while acting as a stretcher-bearer in No Man's Land, Amiens, on October 12, 1918.

James Jellis Page, thirty-two, was born in Tokyo and enlisted in Long Beach in March 1918. He was killed in France on September 28. A citation by his division stated that "this soldier rendered valuable assistance in combat in the face of heavy machine gun fire. He was killed going forward."

Fred E. Painter, twenty-eight, was killed by a high-explosive shell in the thick of battle on the first day of the St. Mihiel Offensive, September 12, 1918.

James A. Palmer, thirty-five, was killed in action on the Western Front on August 11, 1918.

Chester C. Palmerlee, twenty-six, was killed in action near Troulsol Farm, France, on July 11, 1918.

Walter S. Pawson was killed shortly after arriving overseas in April 1918.

Arthur Lincoln Peterson, twenty-four, was the first U.S. Army soldier from Long Beach to die in action in World War I. At 5:30 a.m. on September 12, 1918, while warning four of his comrades, whom he was leading in a voluntary advance to cut barbed wire entanglements, he was killed in action by machine gun fire. The Long Beach post of the American Legion is named in his honor.

Clifford W. Poland, a member of the 128th Infantry, was killed in action in France on May 31, 1918.

Ivan Leo Price, twenty-one, was born in Alberton, Washington,

Arthur Lincoln Peterson, twenty-four, was the first U.S. Army soldier from Long Beach to die in action in World War I. The Long Beach post of the American Legion is named in his honor.

and later moved with his family to Long Beach. He was with the 5th Marines when he was killed in action in the Meuse-Argonne Offensive on November 3, 1918. The Pullman, Washington post of the American Legion was named in his honor.

Joseph Z. Sawyer, twenty-six, was killed in action in August 1918 during one of the battles that turned back the German advance.

Albert David Schnapp, twenty-six, served with an antiaircraft battalion in the defense of Paris and saw action in St. Mihiel and Meuse-Argonne. He was killed in action at Vigneulles, France, on October 11, 1918.

George S. Simington was killed in France during the Battle of the Argonne.

L.A. Waltlet volunteered for service the day after America entered the war. He saw active service on the Western Front as a captain in the 364th Infantry. In the Battle of the Argonne, he suffered from shell shock, and after three weeks of hospital treatment, he was returned to his company. Three days later, he was killed in action.

Hall W. Watts was killed in heavy fighting in France in August 1918.

Raymond Wortley saw action as a captain beginning in June 1917. He was involved in the Sommeville, Anseville and Cantigny engagements; in the Montdidier-Noyon defensive; and in fighting at Soisson, the Second Battle of the Marne and the St. Mihiel and Meuse-Argonne Offensives. He was injured three times in battle and died as a result in October 1918.

William Young, twenty-one, died in action on a battlefield in France after only two weeks of active service on the Western Front.

THE ARMISTICE CHRISTMAS

The Great War was newly ended and peace reigned, possibly forever, over Long Beach and the world.

The local paper's editorial on Christmas Eve 1918 read like a vintage newscast:

> *Uncle Sam, as the personification of the government, people and institutions of the United States, has been Santa Claus to the world. His entrance into the war in great force made possible the great victory this year—made possible this glorious Christmas of peace and assured*

*freedom of the world. Uncle Sam, in effect, therefore, has put peace in
the Christmas stocking of Mother Earth.*

In the fall of 1918, Arthur Lincoln Peterson, who was killed in France
by machine gun fire, became the first of seventy-seven lives that Long
Beach gave to the war effort.

But it was Christmas now, a time to dwell on the happiness of the
season, a time to count blessings and look to the new year with hope.
All up and down the boulevards, in the young town's finest houses, early
prominent families—the Walkers, the Heartwells, the Grundys—were
celebrating the holiday.

Augusta Lewis's son Glen, who had been stationed in England since
July, had just been discharged, and Mrs. Lewis was hosting a holiday
party for him at her home at 923 East Fourth Street.

Philander Elsworth Hatch, an influential Long Beach banker, and his
wife, Eloise, also had reason to rejoice. Their son John Ellsworth had
been discharged the week before Christmas. They celebrated at their
home at 2203 Ocean Boulevard.

Mayor and Mrs. W.T. Lisenby had hoped their son William Jr. would be
discharged in time to be home for Thanksgiving. They were disappointed
and disappointed again when he wasn't released in time for Christmas.
He finally came home on January 22, 1919.

For the first time in anyone's memory, there was no big gathering at
Rancho Los Alamitos, the sprawling estate of Fred Bixby where relatives
and friends had always come together on Christmas Eve for dinner.

All preparations were underway for the usual celebration when
daughters Elizabeth and Deborah came from Piedmont boarding school
and, as the newspaper noted, "promptly fell victims to the prevailing
illness, which placed the house under quarantine."

(An outbreak of influenza—"the prevailing illness"—struck the nation
in the late fall and winter of 1918. In Long Beach, where it was less
severe than in some communities, 522 cases were reported. Twenty-three
people in the city died from the disease.)

For those without an invitation to one of the private Christmas
gatherings, the Hotel Virginia, the city's most elegant hostelry, was
offering a Christmas dinner. However, at a rather dear two dollars a
plate, the dinner was only for the fairly well-to-do.

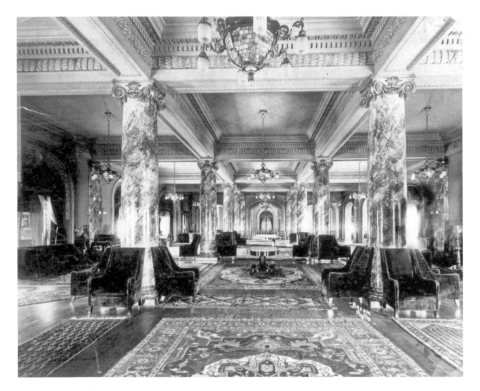

If you could afford the steep two-dollars-a-plate dinner, the Hotel Virginia, the city's most elegant hostelry, was the place to go for Christmas dinner in 1918.

For those down on their luck, there was seasonal relief.

At six thirty on Christmas morning, the local lodge of the Elks visited the homes of seventy-five families ranging from two to nine people to deliver a week's worth of food to each person. Members of the Salvation Army spent Christmas handing out 150 Christmas baskets to the needy at the organization's hall at 327 Locust Avenue. The members of the Girls' League of Polytechnic High School spent part of their Christmas morning distributing baskets of food and gifts to twenty-five homes. And as for our soldiers who were still away, the local chapter of the Red Cross had shipped 1,450 boxes of seasonal goods and gifts.

Christmas card sending was in full swing that year. According to the *Press*:

> *Long Beach people wrote 54,704 letters on the Sunday before Christmas which went out through the local Post Office yesterday. This establishes*

*a record for this municipality. The number last year was 38,960. This
year's figure means a letter for every man, woman and child in Long
Beach, and a few extra missives thrown in for good measure.*

And what dreams of children were in those letters in the days before
computers and electronics? Rag dolls and baseball bats were the usual
standbys, but fads and seasonal enthusiasms it seems have always been
with us.

Again from the *Press* on Christmas Eve:

*There is a constant demand for brand-new toys, and especially something
that will "wind up and go." The American idea of rush is carried out
even in the toys, and no one understands this better than the toymakers.*

*There seems to be no end to the mechanical toys that are invading the
shops. Automobiles that are propelled by steam are decidedly passé, and
in place of them are realistic steamboats that are almost as complete
as the ocean liner. Then there are the motorboats that run on the same
principle. The speed that can be obtained from these boats is marvelous,
especially when one considers the minute parts that compose them.*

Christmas 1918 was the first for the citizens of the growing town of
Long Beach, where "Home for Christmas" and "Peace on Earth" meant
something deeper than it had in the past, and the local paper echoed the
sentiments of its readers: "The *Press*, with the utmost zeal and jubilation,
extends Christmas greetings to all its good friends and invokes for each
and all a holiday radiant with the joy of peace and promise of better days
for all the world."

OUR BELOVED FOUNDER

Although he is generally acknowledged as the founder of Long Beach,
little is known about William Erwin Willmore. In fact, most of the
literature on Willmore has more to do with his failure than with his
success as a builder of a city.

In 1855, shortly after his mother died, Willmore came to America
from England with his father. His father died sometime after their arrival

in the States, leaving William to look after himself. He never married, and not much is known about his background other than that he was said to have been a schoolteacher.

His story picks up in California, where he was hired as a manager for the California Immigrant Union (CIU), formed to encourage the subdivision of large landholdings into smaller farming and housing tracts. In that capacity, in 1880 he became acquainted with Jotham Bixby, who approved Willmore's plan to develop part of Bixby's Rancho Los Cerritos into farm acreage and a town site, which would become Willmore City and, later, Long Beach.

The CIU later abandoned the project, but Willmore stayed on—and without the financial padding to weather the initial years of economic hardship, he lost the town of his dreams, Willmore City.

Frank E. Cook, one of the pioneers of late nineteenth-century Long Beach, knew Willmore from those early days. In a 1932 interview with the *Long Beach Sun*, Cook recalled:

> *Mr. Willmore was a man of great vision, as his ideas about wide streets and various other matters in town planning demonstrated.*
>
> *He dropped out of sight after being forced to relinquish his Willmore City option, and when he returned some years afterward he told me a surprising story.*
>
> *He said he couldn't remember what had happened in connection with his departure from Willmore City, but he "came to" in a boxcar in Southern Arizona, badly beaten up. How he got there, he declared, he didn't know.*

According to early Long Beach historian Jane Harnett, Willmore had, in Arizona, suffered a sunstroke,

> *which left him broken both in mind and body. Many years later, he returned, a pathetic figure, to make his home in Long Beach. The wonderful development of the town he founded seemed to arouse in him no sensation of pride or joy. The change in name was the heaviest blow of all. This he ascribed, quite within reason, to personal spite against himself, and he never tired of recounting his grievances to any who were kind enough to listen to him.*

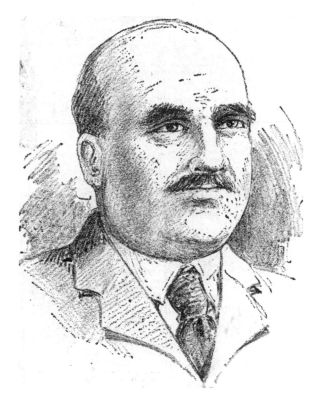

Long Beach founder William
Willmore never sat for a
photograph or a portrait.
This is a composite illustration
drawn from descriptions.

In the 1930s, local historian Walter Case wrote that Willmore

> *became an inmate of the County Farm as a result of his destitute*
> *circumstances and his breakdown of health. But after a short time, old*
> *friends, interested in helping him leave the institution and make his own*
> *way, contributed to a fund to set up his own business.*

Frank Cook noted:

> *Mr. Willmore asked me if I would prepare a paper which people might*
> *sign, subscribing money for him to us in starting a business in a little*
> *fruit stand. I did so and started the list with a donation of $2. About*
> *$40 was raised in this manner, and Mr. Willmore opened a stand on*
> *Pine Avenue between First and Second streets. But he was in such a*
> *condition that he couldn't conduct a business properly, and the fruit*
> *stand venture proved a failure.*

According to Case, Willmore was once again "condemned to the County Farm," but on January 16, 1901, just before he was to enter the institution, he died.

In 1913, twelve years after Willmore's death, the Signal Hill Civic League placed a monument over his grave in the Long Beach Cemetery.

CHARLES RIVERS DRAKE

William E. Willmore had a dream that, as it turned out for him, was a bitter failure.

Colonel Charles Rivers Drake had a dream, too, and the difference between the dreamers was that Drake had a lot of money—enough to bankroll his dreams—and a lot of business sense as well.

By the time Drake died in 1928 at age eighty-four, he had completely and unalterably shaped the face and the future of Long Beach.

His legacy included a thriving and spectacular Walk of a Thousand Lights, to which people began referring as "the Pike"; a popular and

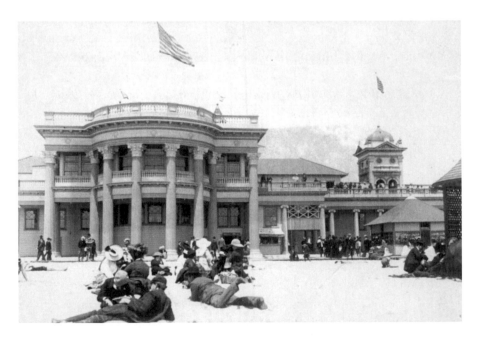

Amidst Charles Rivers Drake's massive development of Long Beach as a tourist town was the cavernous bathhouse on the beach.

refreshing bathhouse; and the city's most prestigious and exclusive social and sporting organization: the Virginia Country Club.

Drake came up with the idea of a deep-water port for Long Beach; he was instrumental in connecting Long Beach to Los Angeles by way of the Pacific Electric Railroad; he ceded Knoll Park, later renamed Drake Park, to the city; and he was a key player in the construction of the truly elegant, by world standards, Hotel Virginia.

And that—all of that—Drake accomplished in what were to have been his retirement years.

Drake was born in Walnut Prairie, near the Wabash River, in Illinois on July 22, 1843. On his father's side, he was a direct descendant of Sir Francis Drake.

In 1863, the twenty-year-old Drake joined the U.S. Navy and served during the final two years of the Civil War under Admiral David Porter, who was charged with gaining control of the Mississippi River for the Union.

At the war's end in 1865, Drake became a druggist clerk in New York City.

Drake reentered the service as a hospital steward in the army and was sent to Fort Lowell, Tucson, in the Arizona Territory in 1871. It was there that he gained the rank of colonel.

Over the next twenty years, Drake's status rose in the territory, culminating with his two-term stint in the upper house of the Arizona legislature.

All during that time, he had been building an empire in real estate and insurance. He co-founded a contracting firm in 1893, beginning a career as a financier, and succeeded in earning lucrative contracts with the South Pacific Railroad. In 1900, Drake was more than amply set up to enjoy an early entry into the golden years of retirement, and as did so many others of that era, he cast an eye toward Southern California.

The fifty-seven-year-old retiree moved to Los Angeles, but his restlessness merged with his business ambitions, and he began buying up chunks of the nearby city of Long Beach, then a seaside town of fewer than three thousand citizens.

The property that Drake snatched up included forty acres on Signal Hill, thirteen blocks and more than 630 lots on the beachfront of the original town site of Willmore City—essentially all the oceanfront from Alamitos Avenue to the Los Angeles River.

It was obvious, even from the viewpoint of the first settlers of the town, that Long Beach would be a superior spot for vacationers. But while others saw little more than a beach, Drake envisioned more than mere natural splendor. He would build a spectacular amusement zone stretching from one end of his expansive property to the other, and he would bring a rail system to transport crowds from Los Angeles to enjoy it.

On the Fourth of July 1902, Colonel Drake, president and general manager of the Long Beach Bath House & Amusement Co., presided over a gigantic civic celebration that saw the inaugural run of the Pacific Electric streetcar service into Long Beach and an early showing of the bathhouse. On that day, sixty thousand people visited the town of three thousand, which was in no way able to lodge all those guests who wanted to spend the night. Many slept on the beach.

The year 1902 also saw the foundation laid for the Pike—the Walk of a Thousand Lights.

Four years later, another city father, Jotham Bixby, laid the cornerstone for what would become the pride of the city: the Hotel Virginia.

At first it was to be called the Bixby Hotel. The original directors included Drake, Jotham Bixby, Fred H. Bixby, George H. Bixby, George Flint, C.L. Heartwell, J. Heartwell and C.J. Walker.

On November 9, 1906, ten workmen were killed and twenty-five injured when portions of the fifth and sixth floors of the hotel collapsed during construction.

Afterward, the hotel's name was changed for a variety of reasons, not the least of which was the fact that the Bixbys did not want their name attached to Long Beach's first big disaster.

The Hotel Virginia opened in 1908 with a dinner and a ball for seven hundred guests. The $1.25 million hotel's opulent lobby was lined with marble columns, a curved marble stairway and fine oriental rugs.

Furnishings, many imported from Europe, were carved from rosewood, mahogany and walnut. The grounds, bulked up by trucking in thousands of loads of soil, were sculpted into lawns and gardens.

The Virginia's H-shaped construction gave all the rooms a view of the Pacific, and many also had views of the mountains to the north. For any moneyed tourist or visiting businessman, there was never any question about which hotel would be selected for a night's or a week's lodging—at

a pricey $8.50 a night, the exorbitance of which was tempered by the fact that the price included dinner.

Next on Drake's list of accomplishments came the Virginia Country Club. Drake supplied the social organization with its first home near Anaheim Street by what would later become Recreation Park. He bought up 15 memberships, at $25.00 each, plus $2.50 monthly fees, for Hotel Virginia guests. When half of the 119 charter members dropped out after the inaugural year, causing the club to spiral into debt, Drake paid the bills to keep it afloat. In those days, golf hadn't quite come into vogue, and most of the club's members preferred bicycling and horseback riding.

In 1921, the country club moved to its present-day location, tucked behind a swanky neighborhood some distance north of town, and Drake helped secure the property that would become the club's golf course. For twenty years, Colonel Drake served on its board of trustees and was frequently pressed to become the president of the club. Though

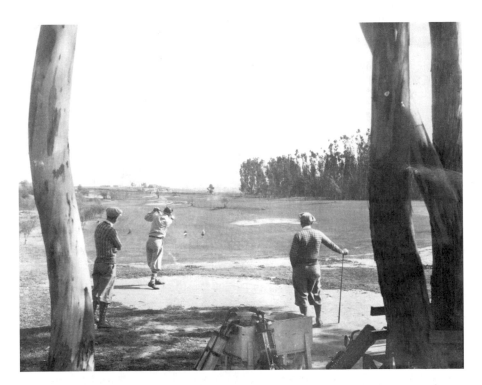

Virginia Country Club golfers teed off at what today is the Recreation Park Golf Course. Drake, who never golfed, moved the country club to its current location in 1921.

well known as the "father of the club," Drake consistently declined the position of president because he simply didn't like to play golf—in fact, he never golfed in his life—and he believed the club's president "should always be a man who enters into the spirit of the game and all the other activities for which the club was formed."

On June 16, 1928, Drake, surrounded by his wife and five of his eight children, succumbed to heart disease at 9:00 p.m. in his room in the penthouse suite of the Hotel Virginia.

In the next day's *Press*, a front-page obituary read, "Colonel Drake, nearly 85 years old and vigorous almost to the end, fell into a peaceful last slumber while the dance music from the ballroom of the hotel he founded and cherished, floated from the windows below."

The next few years were bleak for Long Beach and the nation as the country was rocked by financial ruin. The beautiful excesses of the hotel mocked the impoverished citizenry. In February 1933, broken-down and gutted, the hotel was finally destroyed and its rubble carted away, saving the once-glorious structure only from the earthquake that would devastate the city one month later.

Say Hi to the Lowes

You drive around town today and you run across big names from Long Beach's past—from the original Spanish land grantees, Stearns and Temple, to myriad Bixby pioneers and their distaff side, the Hathaways.

Colonel Charles Heartwell has one of the biggest parks in Long Beach named after him, and the Wardlow family has a major thoroughfare and another large park bearing its name.

A good pick for Long Beach's most overlooked man—throw in his wife and you might have the most overlooked couple as well—would be William Wallace Lowe, whose wife, Belle, even if she didn't do anything else, was the person who came up with the name for Long Beach. OK, maybe it was an obvious choice, with the long beach pretty much being the first thing any visitor in town saw in the village's earliest days, but still, she managed to get the name changed from Willmore City. The name Crescent City was the runner-up when the Lowes and other early residents held a meeting to discuss civic nomenclature in 1884.

The man of the house, though, was a true pioneer in virtually every sense.

W.W. and Belle Lowe read about Willmore City in an advertisement in a Los Angeles publication and decided to pay the little town a visit in the summer of 1884. They came in a carriage with their two daughters and, it being an all-day drive, decided to spend the night by the seashore.

In local historian Walter Case's 1927 book, *Long Beach & Vicinity*, the author noted that "Pine Avenue was yet only a wagon track" when the Lowes rolled into Willmore City. "The weeds on either side reached almost to the horse's back as the family drove into town...At the end of the street, horse and wagon came to a halt in the shade of a house on the northeast corner of Pine and Ocean."

Lowe, long plagued by asthma, slept well for the first time in months, thanks to the proximity of the beach and the bracing salt air, and decided to make his home here.

Using money he'd made in the livestock and grain business in his home state of Nebraska, Lowe bought the northeast and northwest corners of Pine Avenue and Ocean Boulevard (for a total of $3,300). Just north of the house, he built the first store in the town for general merchandise, where he sold all manner of dry goods, from darning needles to plows. He soon branched out, offering groceries as well, making Lowe's Store pretty much the only shop the town needed in its early days, when its population was around three hundred.

Lowe's Store became a clearinghouse for the town. The nearest post office was in Wilmington, and whenever a Willmorian had occasion to visit Wilmington, he'd return with the locals' mail and drop it off with Lowe, who would toss the mail into a cracker box in front of his store for everyone to sort through. Shortly, Lowe petitioned the government for a post office. The petition was granted, and in 1885, Lowe became Long Beach's first postmaster.

And he became Long Beach's first treasurer upon the 1888 vote by Long Beach's citizens to incorporate (the election result was 103 in favor, 3 against).

In addition to being the first serious businessman on Pine, Lowe was also active in the city's religious and fraternal arenas. He was a charter member of the First Congregational Church; the first president of the Long Beach Realty Exchange, formed in 1887; and an organizer of the

first Masonic Lodge in Long Beach. Belle, too, was influential past the mere naming of Long Beach. She was instrumental in setting up the first public school in town, held in a tent at the corner of Pine Avenue and First Street.

W.W. Lowe passed away on December 3, 1910. His widow died on April 8, 1918.

A PHYSICIAN OF FIRSTS

When the Harriman Jones Clinic restoration project and the building's foremost preservationist advocate, Rae La Force, were honored with Long Beach Heritage Awards in 2002, it gave the citizens of Long Beach yet another opportunity to be grateful for the very existence of that venerable clinic, to say nothing of its founder.

Over the years, the clinic's name has been frequently and mistakenly hyphenated as "Harriman-Jones," as if the project were the work of two men when actually it was just the one: Dr. W. Harriman Jones.

Dr. Harriman Jones wrote the city's first public health code and battled unsanitary conditions and contagious diseases, resulting in the establishment of the first sewers in the city and the first vaccinations administered here.

And had the establishment of the clinic been his sole contribution to Long Beach's medical history, he would still be among the greats in the city's lore. But while the clinic was perhaps his crowning achievement, he accomplished so much more that he is nothing less than the father and chief practitioner of medicine in Long Beach.

Born in Battle Creek, Michigan; raised in Oakland; and educated at Cooper Medical College (later Stanford University), Jones came to Long Beach, population three thousand, fresh out of college in 1902.

He was the town's fifth doctor, but he was, right from the start, its best. Once (it's not the kind of thing that's likely to happen twice), Jones performed an emergency appendectomy on a patient using as instruments only parts from a nearby sewing machine.

If that was a first, Jones was involved in several other firsts, all less weird but more noteworthy.

Most importantly, Jones was the town's first health officer, receiving a stipend of twenty-five dollars a month. He wrote the city's first public health code, and his self-imposed mandate during his eight years at the job—to battle unsanitary conditions and contagious diseases—resulted in the establishment of the first sewers in the city and the first vaccinations administered here.

Jones built the first hospital in Long Beach, a small building at 327 Daisy Avenue, and the first electric streetlamp in the city burned in front of that hospital.

With others, Jones organized Long Beach Hospital on Tenth Street and Linden Avenue, which subsequently was sold and became the site of today's St. Mary Medical Center.

He joined other doctors in organizing Seaside Hospital at Broadway and Junipero Avenues, which later moved to Fourteenth Street and Chestnut Avenue. For years, he served as chief of staff for Seaside, which would evolve into today's Memorial Medical Center.

Unbelievably, Jones had time for socializing. He was one of the founders of the Virginia Country Club and the Long Beach Elks. He squired friends, socialites and potential contributors around the coastal waters aboard his seventy-two-foot yacht *Hoqua*.

Throughout his career, his dream was to build a clinic and hospital in which costs could be kept to a minimum, making medical care accessible to all by forming an association of specialists practicing together under one roof.

The Harriman Jones Clinic on Cherry Avenue opened on October 15, 1930, with a staff of fifty-three, including fifteen doctors. The clinic hospital featured a spacious lounge with high-beamed ceilings, mahogany woodwork and tiled stairways.

He worked with noted local architect Kenneth S. Wing (who had designed many gorgeous homes in Bixby Knolls and Los Cerritos and who would later apply his talents to the design of several buildings at Cal State Long Beach, the current Long Beach City Hall and the Terrace Theater) to build the Harriman Jones Clinic at 211 Cherry Avenue, in a tree-lined neighborhood across from Bixby Park.

The building was based on the design of an Italian villa so it could be sold and used in some other capacity should the clinic fail.

Opened on October 15, 1930, with a staff of fifty-three, including fifteen doctors, the clinic hospital featured a spacious lounge with high-beamed ceilings, mahogany woodwork and tiled stairways.

It was an immediate success, and it remained successful for decades, long after Jones retired in 1941. The pioneering physician enjoyed his retirement in Long Beach until he died on June 20, 1956, at the age of 80.

Old News Is New News 1

During the course of the sort of research that, especially during, my annual performance evaluation, I can only describe as "exhaustive," I run across little bits of ancient news that can't quite carry an entire article on their own. Eventually, the day comes when I have enough of these to fill up a column.

What follows are items from various old Long Beach newspapers.

"King Kong" Holds Interest on State Theater Program
The selection of the most unusual picture of the year, the one presenting the strangest theme and the most daring plot was not difficult. "King Kong," current screen attraction at the State Theater, was chosen without a moment's indecision, for it presents the spectacle of a mammoth ape escaping on Broadway, New York, hurling street cars and automobiles and humans in the air as if they were so much chaff.
—Long Beach Sun, *June 3, 1933*

Bumped by Iceberg at Sea
Halifax, Nova Scotia—With its 1,300 passengers safely transferred to another vessel, the White Star liner Titanic, *the largest vessel afloat, this afternoon is slowly approaching this port following a disastrous collision last night with a monster iceberg about 900 miles east of New York…*

The fact that the Titanic *is the world's biggest vessel is probably the only thing that prevented great loss of life…Reports received concerning the collision are meager. It is not known just how the accident occurred or whether the collision was followed by a panic.*
—Long Beach Press, *April 15, 1912*

Nation Stunned Today by Appalling Loss of Life to Passengers Aboard the White Star Titanic, *Sunk in Mid Ocean*
—Long Beach Press, *April 16, 1912*

Long Beach Has Possibly Oldest of Living Twins
Living at 236 Magnolia Ave. are two remarkable men, probably the oldest twins living. They are Thomas G. Holmes and Robert S.

Holmes, who will be 76 years old Feb. 28. Both men are hearty and well preserved and resemble each other greatly. Both have flowing, white beards. Of eight brothers in the family, Thomas G. was the only one who ever married. His twin has never been separated from him long at a time, and at the time of the marriage it was understood they were not to be parted.
—Long Beach Press, *February 3, 1908*

LOCAL NEWS IN PARAGRAPHS
Rubbish Pile: Arrest will probably follow the discovery of the identity of the individual who left a lot of rubbish in Second Street between Atlantic and Linden avenues.
Chicken Complaint: Mrs. C.A. Simpson, of 515 Ohio St., has petitioned the police to put a stop to the chicken nuisance in that neighborhood. It is said that the chickens roam about the streets and lawns with all the abandon of absolute ownership and have become a decided nuisance.
Keys and Coins: An old man strolling along the Pike yesterday found a small purse containing 20 cents in coins, and a key, which he turned over to Policeman Brown, who left it at the police station.
—Long Beach Press, *June 3, 1911*

THEY LIVED ALOFT

Long Beach's gallery of flying stars stacks up against any city's in the world. Some of the greatest names in the history of flight took off from Long Beach or landed here, and that doesn't mean hopping on JetBlue for a quick flight out of town.

Here are a few of the more notable names in Long Beach aviation history.

CALBRAITH PERRY RODGERS: Long Beach's enthusiasm for flight could be said to have begun on December 10, 1911, the day Calbraith Perry Rodgers's flight ended in town, just a week shy of the seventh anniversary of Wilbur and Orville Wright's historic jaunt over the dunes in Kitty Hawk.

Rodgers could see no good reason why he shouldn't be the first to fly from coast to coast. The flier hustled up a sponsor, the soft-drink Vin Fiz; hopped aboard his Wright biplane that bore the sponsor's name;

and began his flight from Sheepshead Bay, New York, on September 17, 1911.

The transcontinental journey was a series of bumps, hops, crashes and rebuildings. It took sixty-eight separate flights—twenty-nine in Texas alone—to make it across the country. Along the way, guided by railroad tracks, Rodgers landed in parks, prairies and hillsides. Other times he didn't "land" so much as crash. Sixteen times his plane fell to the earth in a heap and had to be rebuilt by the pilot.

Finally, on December 10, 1911, with his leg in a cast and his crutches strapped to a wing of the plane, he made it to the Long Beach shoreline, dipping his wheels in the Pacific and ending his journey.

Rodgers died in a plane crash when his craft smashed into the ocean at Long Beach on April 3, 1912.

EARL DAUGHERTY: Daugherty was the first Long Beacher—and the eighty-seventh person in the country—to be issued a license to fly, and he about wore out that license. In his lifetime, he carried more than

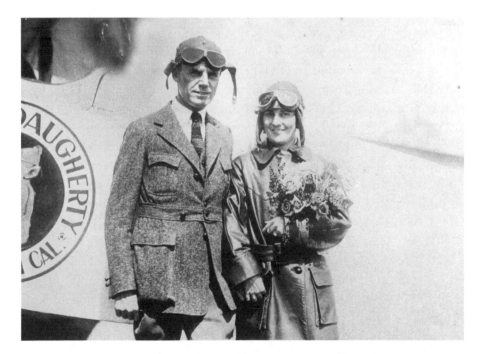

Earl Daugherty and his wife, Kay, both noted Long Beach aviators. "We absolutely lived and ate aviation in those days," said Kay.

twenty thousand passengers—mostly one at a time—flew more than five thousand hours and covered some 350,000 miles in the air.

Daugherty moved with his family to Long Beach from Des Moines, Iowa, in 1902, when he was fifteen.

He was a frequent flier, delighting the guests at the beachfront hotels, including the swanky Hotel Virginia. When World War I started, Daugherty, already an old hand at the still-new field of aviation, was pressed into service to train navy pilots, first in Long Beach and then at Rockwell Field in San Diego and at March Field near Riverside.

After his discharge from the service, he bought land for an airfield outside town near American Avenue (now Long Beach Boulevard) and Bixby Road and began thrilling visitors, whom he would take on "an aerial joyride in Cloudland," as his billboards advertised.

As his reputation and dreams grew, Daugherty eventually persuaded Long Beach to build a municipal airport, which it did in 1923. It was called Daugherty Field, after the man who inspired it, who first landed at it and who became its first commissioner.

On December 8, 1928, Daugherty, then forty-two and delighted with his new toy, a Laird biplane, took two friends up for a routine spin. It ended tragically when the experienced pilot's plane crumpled during a barrel roll and crashed in an open field about a mile north of the airport.

He left behind Kay, his wife of five years.

KAY DAUGHERTY: Catherine (Kay) Ellen Hall grew up in Long Beach after moving here with her family from North Platte, Nebraska, when she was a toddler.

She fell in love with the handsome aviator Earl, whom she met while she was working in a downtown department store. She shared Earl's enthusiasm for flying, and the couple took off on September 20, 1923, with Reverend Henry Kendall aboard, to become man and wife in the clouds over Long Beach at an altitude of three thousand feet.

"We absolutely lived and ate aviation in those days," Kay told a reporter later. She and her husband flew together and apart, touring around the West and operating the aviation school in Long Beach. Kay was only a wife for five years, but she remained Earl's widow, never remarrying, for more than seventy years. She poured all her energy into flying during the several decades after her husband died. She ran her own flying service out of Long Beach Airport, and during World

War II, she was executive director of the Long Beach squadron of the Civil Air Patrol.

After retirement, she opened and managed the International Garden Hotel at the airport until she suffered a stroke at the age of 92, when she moved to Exeter, a small town between Bakersfield and Fresno. She died on February 25, 2000. She was 101.

JOHN MONTIJO AND AMELIA EARHART: One of the first Latino aviators, John Montijo was also one of the city's pioneer flyers, spending most of his time hanging out with Earl Daugherty at the landing field back in the days before the airport was built. One of Montijo's friends included the young flier Amelia Earhart, who visited him at Daugherty's School of Aviation.

Earhart initially studied piloting with Neta Snook, the first female graduate from the Curtiss School of Aviation, but Snook retired to raise a family before Earhart was able to fly alone. So Montijo gave Earhart her final lessons, which he provided in return for Amelia babysitting his son.

Montijo went on to play an important role as co-founder, with Daugherty, of the Long Beach Airport. He bought the first hangar at the facility (which he soon sold to Daugherty), and he became the second municipal aviation commissioner (after Daugherty) in 1929.

After Earhart became the first woman to make a transatlantic solo flight in 1932, she wrote to her old flying coach, "Flying the Atlantic isn't any more difficult than any other trip, providing the engine keeps going."

DOUGLAS "WRONG WAY" CORRIGAN: Born in Galveston, Texas, in 1907, Douglas Corrigan moved to Los Angeles when he was twelve. He learned to work wood, and after building houses for a while, he learned to fly.

Corrigan was as awed as any American when Lindbergh made his historic New York–Paris flight on May 21, 1927. But being a good Irish lad, he might've wondered, "Why Paris? Why not Ireland?"

He had petitioned the Department of Commerce in 1938 for permission to fly from New York to Ireland, but because of the shoddiness of his virtually homemade craft, and lack of instrumentation, permission was denied.

Back in Los Angeles, he informed anyone who cared that he was preparing instead for a round-trip flight from Long Beach to New York and back. He fueled up at Long Beach Airport with 252 gallons of gas on

Douglas "Wrong Way" Corrigan
on his return to Long Beach
Airport after flying across the
Pacific to Ireland. "I guess nobody
believes me."

July 8, 1938, in his Curtiss-Robin, a smaller plane than Lindbergh's. He made good time to the East Coast: twenty-seven hours and thirty minutes.

Nine days later, as officials still refused to let him cross the Atlantic, Corrigan motored on the runway at Bennett Airport in Brooklyn as a handful of attendants watched. He explained later that there had been a haze near the ground, the compass had leaked all its fluid and he never could see the ground.

"I never did get out of the clouds. I couldn't see a thing," he insisted. Still, assuming he was headed west, he continued to fly for twenty-six hours. And then he could see: "A lot of grass, there were some cobblestone streets and some thatched roofs. Nobody was on the beach, and there weren't any orange trees. Imagine my surprise when I found it was Dublin!"

Yes. Imagine.

He never stopped telling his story, always the same. He meant to fly back to Long Beach, but he ended up in Ireland. "And still they keep asking me," he told the press. "I guess nobody believes me."

Aviators Who Died Trying

They've always died, the explorers and pioneers who have sought the ends of the skies. From Icarus to the crew of the *Columbia*, tragedy has always waited in the wings.

Long Beach was an unusually active spot in the nation in the earliest days of aviation, and as a result, it's had more than its share of airplane crashes.

Calbraith Perry Rodgers bought the first plane built by the Wright Brothers' airplane company and was trained to fly by Wilbur and Orville themselves. Rodgers made aviation history with what the papers called a "stupendous achievement" making the first coast-to-coast airplane flight. It was far from a nonstop flight, however.

Rodgers started from Sheepshead Bay, New York, on September 17, 1911. About three months later, on December 11, 1911, he landed his biplane on the central beach in Long Beach, climbing out of his cockpit and hobbling off on crutches before a crowd of some sixty thousand spectators.

The trip was stretched out by more than a dozen crashes and breakdowns along the way, including crash number fifteen, when his plane went down on the Orr Ranch near Compton. The pilot spent a month in a Pasadena hospital recuperating from two broken legs, a pair of busted ribs and a broken collarbone.

On April 3, 1912, Rodgers, who had remained in Long Beach and made frequent short flights around town, crashed in the surf just west of the Pine Avenue Pier and died instantly.

Witnesses said he'd appeared unable to turn his plane upward after having made a sharp dip.

In January 1910, America's first air meet was held just outside town at Dominguez Field. More than twenty thousand people came to watch— Long Beach schoolchildren were given the day off to witness the historic event—as all manner of aviation records were set, including Lewis

Paulhan's climb to 1,100 feet and Charles Hamilton's endurance record of fourteen minutes, fifty-three seconds.

The following year's show was struck by tragedy, however, when local pilot Archie Hoxsey bagged the Long Beach Chamber of Commerce's trophy for altitude, climbing to a height of 7,500 feet before descending into a series of crowd-thrilling spirals. He was 800 feet from the ground when he tried one more spin, but according to experts, he got caught in crosswinds, causing the crash that killed him.

For several days, the trophy he won was displayed in the window of the R.C. Anderson jewelry store on Pine Avenue, draped in mourning.

When Cal Rodgers made his historic landing in Long Beach in December 1911, he was accompanied on the final leg by a couple of young Long Beach pilots who had received their pilot's licenses earlier in the year: Earl Daugherty and Frank Champion. Both rose to the top flight of the nation's aviators in their careers. Champion was a familiar sight in local skies, as was his pal Daugherty. And there's no telling how great an aviator Champion might have become had he lived to log more hours in the cockpit.

Even as a rookie flier, he was making good money. In 1911, he was paid the huge sum of $1,200 just to make a couple flyovers at the Pike. A few months later, he died in an exhibition flight in Japan.

Earl Daugherty's exploits have been chronicled here countless times. The most prominent of local aviators, Daugherty founded what would become Long Beach Municipal Airport—originally Daugherty Field.

He flew almost every day for a decade and a half, though his appearances over the town never ceased to be thrilling sights for tourists and locals. He became skilled at stunt flying and made a living selling "aerial joyrides in Cloudland" for a relatively whopping ten dollars. For twenty-five dollars, he'd throw in "loops, vertical reversements, tail spins and other thrills."

During his career, he carried more than twenty thousand passengers, flew more than five thousand hours and covered more than 350,000 miles in the air. And yet...

On December 8, 1928, the forty-two-year-old Daugherty was anxious to take his new Laird biplane out for a few stunts. He wanted to practice alone, but local businessman Elmer Starr and *Press-Telegram* city editor Warren Monfort talked the pilot into taking them along for some thrills.

On December 8, 1928, the forty-two-year-old Daugherty took local businessman Elmer Starr and *Press Telegram* city editor Warren Monfort for a ride in Daugherty's Laird airplane. In a barrel roll the plane suddenly crumpled and crashed in an open field about a mile north of the airport, killing all three instantly.

The Laird climbed 3,200 feet before going into a barrel roll when the left wing of the plane suddenly crumpled and the fuselage and right wing shot earthward. It landed in an open field about a mile north of the airport, killing all three instantly.

According to news accounts, the aircraft's engines were roaring during the descent. The reporter opined that "either Daugherty opened up his motor full on to try to bring the ship out of the fatal plunge or did it to hasten the end when he saw the wing torn off, keeping his oft-repeated intention to brother fliers that 'If I know it's my last dive, I'll make a good job of it.'"

FIRE!

For more than one hundred years, the Long Beach Fire Department has been one of the best and most progressive departments in the country. For starters, in 1907, the fire department became the first to use firefighting vehicles on the Pacific Coast—a pair of converted Rambler automobiles. And on a more aesthetic level, the department pioneered the idea of designing its stations in the architectural styles of the neighborhoods they served.

In the earliest years of the city, however, the department wasn't exactly the pride of the West Coast. In 1901, Long Beach (population about 2,300) owned a couple of hose carts that moved as quickly as the volunteers—any able-bodied man or boy—hauling it.

In 1902, a more organized volunteer squad was begun. There was no firehouse to speak of. What equipment existed was stashed behind city hall and maintained by a fellow named Smith Shallenberger, who was also jailer, janitor and general utility man around city hall.

What sparked the town's firefighting unit into action was a blaze that destroyed the Municipal Pavilion in 1905, a devastating $10,000 disaster that shone a harsh light on the inadequacies of a small volunteer unit trying to serve a growing city.

Long Beach voters authorized a $30,000 bond issue that year to beef up the department and acquire better gear.

In 1906, headquarters—Fire Station No. 1—opened at Third Street and Pacific Avenue. The new equipment included a hose wagon with chemicals under the seat, sometimes referred to as a "chemical wagon" or, simply, a "chemical." Two horses drew the wagon. Also powered by a pair of ponies was a new steamer wagon.

The horses were kept in stalls at the back of the new modern firehouse.

The two vehicles rolled together on calls, almost invariably accompanied by an entourage of perhaps "helpful," but more likely merely curious, civilians riding on bikes, hay wagons or a new-fangled automobile.

To slice valuable seconds from the department's response times, the horse stalls were equipped with state-of-the-art automatic halter-droppers. When an alarm rang in the station, bars in front of each horse would rise, and the horse's halter apparatus would be released, freeing the horse so the driver could rig it to the wagon.

But the modern equipment wasn't always what it was cracked up to be, much to the delight of the town's citizens, who loved a good foul-up almost as much as they loved accompanying the department on a call to a blaze.

One such episode was chronicled on the front page of the March 31, 1906 edition of the *Daily Telegram*, beneath the eye-grabbing headline: "Fire on Maine Caused by Gas: Created as Much Excitement as Coming of a Circus":

> *There was enough excitement around fire headquarters to suit the most exacting at about 11:45 today when an alarm came in from Box 27. One of the pegs failed to drop as it should and as a result one of the black horses driven to the chemical wagon was not released from his halter strap when the alarm came in.*
>
> *The driver ran back to set the horse free, but by that time the animal had become so nervous that instead of stopping under the harness, it galloped on out into the street and cavorted around in front of the building, to the edification of a small crowd.*

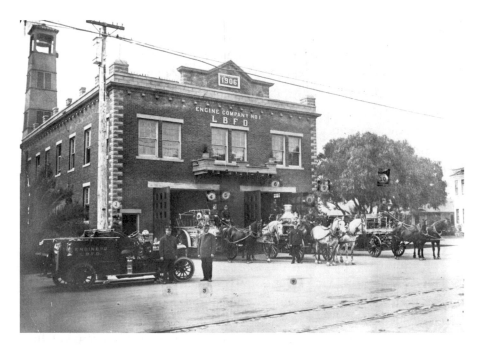

In 1905, fire apparatus bonds in the amount of $30,000 were sold to provide the building of a central fire station along with fire alarm boxes, equipment, a steam fire engine, a hose wagon and a ladder truck. The station opened in 1906 at 210 West Third Street.

But that wasn't what the firemen wanted just at that time, and a number of citizens who had run to the fire hall formed a ring and finally drove the excited horse back into the building. It was then only a second before he was hitched and ready for the run.

By that time, a large crowd had gathered and a gang of excited people, with autos, express wagons, hay racks, buggies and bicycles fell in behind the chemical and joined in the run to the fire. The autos went a-flying, every horse went at a gallop, and every kid on a bicycle made his legs fly. The run was a long and dusty one. The fire, which was perhaps the least exciting thing about the incident, was at 247 Maine, in the residence of Anna E. Kopff. A gas flame caught on some of the furnishings in a room and damaged the furniture and curtains slightly. There was but a nominal loss.

The fire was out when the department arrived.

THE OLDEST PIER ON PINE

Even before the current Pike at Rainbow Harbor came along, developers intent on borrowing against Long Beachers' nostalgia for its youthful days as a tourist town built a Pine Avenue Pier on the waterfront (formerly oceanfront) at the extended foot of Pine Avenue south of Ocean Boulevard.

It's hardly a pier in the local traditional sense. It doesn't, for instance, jut out over the ocean. Rather, it sort of nudges at the gentle waters of Rainbow Harbor near the Aquarium of the Pacific and, yes, near the new Pike.

There are still some old-timers around, however, who recall the later days of the old Pine Avenue Pier when it still clung to the western arc of the Rainbow Pier during the 1930s.

And while that was a glorious pier—a double-decker opened in 1903 and festooned during various eras with pavilions and auditoriums—we're not writing about the old Pine Avenue Pier today but, rather, the *older* Pine Avenue Pier.

The original Pine Avenue Pier opened in 1893 and stood as the first purchase made by the citizens of the fledgling village of Long Beach as an investment toward becoming a resort town. The local press,

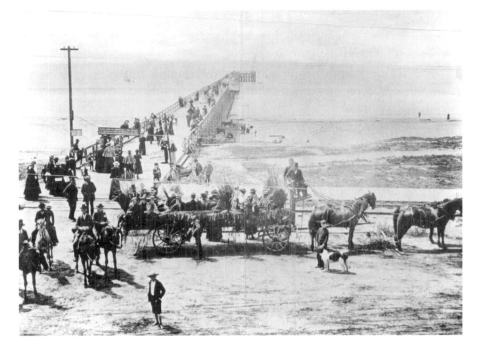

The *Long Beach Eye* editorialized, "We are for the people, and the people want a wharf." The people—Long Beachers voters—backed a $15,000 bond, and the original Pine Avenue Pier opened in 1893.

the *Long Beach Eye*, pushed the pier when the vote to issue a bond for $15,000 for its construction came before the electorate. "We are for the people," trumpeted the paper. "And the people want a wharf," which, apparently, they did, passing the issue by a landslide vote of 120 to 11.

The Pine Avenue Pier was the first municipally owned pier on the Pacific Coast when it opened in the spring of 1893, and it was a spectacular sight, shooting off as it did—seemingly halfway to China—1,700 feet into the Pacific, besting by 1,000 feet the town's first pier, built off the foot of Magnolia Avenue by the Long Beach Land & Water Co. in 1885.

Of course, virtually everyone in town came to the pier's dedication ceremony, described shortly afterward in the press as "the gayest event in the history of town up to then." People from outside Long Beach's boundaries came as well, by buggy and carriage and train. The Southern Pacific, whose tracks ran down West Second Street (now Broadway)

downtown, ran a special midnight train to get out-of-towners home after the celebration ended.

"The demands of the pleasure-seeking public has been met at all points," trumpeted a reporter.

It did well what piers are meant to do. It gave strollers a chance to walk out over the waves, and it provided a perch for anglers. At its far end, the pier had a landing float for fishing boats, which could be seen all day and evening bobbing at anchor near the pier.

The fishin' was good. Or, in the loftier words of a writer of the era: "The disciples of [Izaak] Walton have every opportunity to gratify their ambitions from the sides of the wharf, and old ocean gives up the finny tribe with endless generosity."

In 1899, the pleasure of the pier increased with the addition of a $4,000 pavilion on the shore end of the pier, offering shelter from the elements and a venue for music and nightly dancing.

The nightly dancing became twice-weekly (Tuesday and Saturday) dancing after First Congregational Church pastor the Reverend Sydney C. Kendall protested the frequency of revelry at the pavilion. The structure, he said, was "built by the taxpayers of Long Beach, the majority of whom not only do not dance themselves but regard dancing as actually an offense." Two evenings a week was decided upon as offense enough.

The pre-breakwater surf ravaged the pier, while shipworms gnawed at the pier's pilings. It racked up thousands of dollars in annual repair costs.

By 1903, the citizenry had its eye on shinier plans: a new double-decker Pine Avenue Pier that would cost $100,000.

It was a city that loved its piers. A bond issue to pay for the new—and now old—Pine Avenue Pier passed by a vote of 452 to 14.

Other piers of the past include:

THE DOUBLE-DECKER: The double-deck Pine Ave Pier was completed in November 1903 amid the sort of fanfare that you don't see under any circumstances these days. California governor George Pardee turned a golden key to open the pier on November 12 as, the papers said, "the band played and men and women shouted."

The opening was also made grand by a barbecue, yacht races, a football game, a float parade and dancing on into the night.

The double-decker (bottom for cars, top for folks on the stroll) was paid for with a $100,000 municipal bond, which took care of the actual construction, but the funds began dwindling over the years as the unbroken surf pummeled the pier in a series of storms, including a freakish Fourth of July storm in 1910 that ripped out an eighty-foot section of the 1,800-foot pier.

Further damage occurred in storms in 1912 ($25,000 in damages) and 1919 ($14,000). Still, the pier stood until its final remains were swept away by heavy surf in 1934.

DEVIL'S GATE: Outside town, to the south, the Belmont Heights—or Devil's Gate—Pier opened on Christmas Eve 1915, jutting out from the bluff at Thirty-ninth Street.

Unlike the Pine Avenue piers, which were adorned with sun parlors and pavilions, the Belmont Heights pier was a no-nonsense way to walk out to where the fish live. It was a sturdier little pier, though, and managed to hang on for more than fifty years, even overlapping, to an extent, the construction of the current Belmont Pier, which opened in February 1967 at a cost of $1.5 million.

THE RAINBOW PIER: The king of all Long Beach piers was the Rainbow Pier, a 3,800-foot semicircle (imagine, if you will, the shape of a rainbow) pier that connected Pine and Linden Avenues by way of arcing 1,350 feet into the Pacific.

Built on 333,000 tons of rock, it could hold, according to the chamber of commerce, seventy-five thousand people comfortably. At night, multicolored lights (much like the colors in a rainbow, if you will) reflected off the waters of the Rainbow Lagoon—the water that was trapped within the pier's arc.

Over time, however, the pier was battered, just as all piers are (except, of course, today's Belmont Pier, which is sheltered by the breakwater) by storms, and tidal motions filled the lagoon with silt and sand. Eventually, the lagoon was filled, and the pier itself was demolished in 1966.

PIKE'S PIER: The Silver Spray Pier wasn't so much a pier as a pleasure platform. The thing was almost square—it was three hundred feet wide and jutted out only five hundred feet from the foot of Cedar Avenue.

As part of the Pike, the Silver Spray's main job was to hold such giant attractions as the venerable Jackrabbit Racer roller coaster, but it also

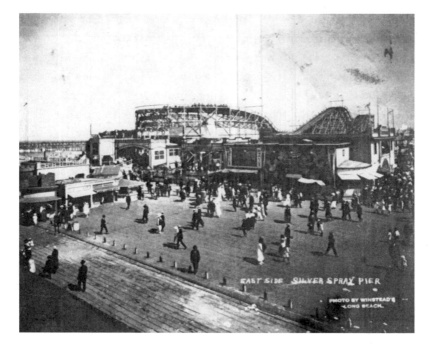

The Silver Spray Pier on the Pike at the foot of Cedar Avenue was home to many of the fun zone's attractions, including the Apache Trail and Dodg'em. It also went by the name of the Neptune Pier and, simply, the Pleasure Pier. It was demolished in 1948.

held such odd sideshows as the Pig Slide (pretty much what it sounds like), a Snake Farm and the Monkey Drome, which featured actual monkeys driving gas-powered cars around for your amusement.

Opened in 1913, the Silver Spray made it through the Pike's glory days of the 1940s—or almost, anyway. It was torn down in 1948.

HISTORY OF DIRECTORIES

Before the cellphone explosion, the highlight of the year, telephone-wise, was the delivery of the new phone book. The size of the unabridged *Oxford English Dictionary*, the latter-day books—the ones that came out just as the telephone, though still tethered to your wall, was offering more and more features, like call blocking, user ID and the like—came with page after page of instructions on how to issue commands and fire up features using the pound and star buttons.

Long Beach's first phone directory came with the phone numbers of all 162 subscribers to the Long Beach Home Telephone & Telegraph Co. in 1903.

The instructions are written with the breathless briskness of *The Mill on the Floss*, and after I absorbed enough to get maybe a C minus on the exam, I descended into the basement to ferret through my archives until I found the oldest Long Beach phone book (because it's called "Directory No. 1," I haven't bothered to look for anything older), which is dated October 24, 1903, and which, at one page, can't properly be termed a "book." It was, however, the Everything Page, with the phone numbers of all 162 subscribers to the Long Beach Home Telephone & Telegraph Co., including a sort of Yellow Part of a Page that advertised the services of W. Clifford Co., dealers in feed & fuel.

But the best part was the set of helpful instructions on how to operate the then-newfangled contraption. Among them:

> *To call, take Receiver from the hook.*
> *When the operator calls for number, give the number desired distinctly, repeating each figure of the number separately.*
> *Face the instrument and talk in a moderate tone directly into the transmitter.*
> *When through talking, return receiver to the hook promptly.*
> *To quicken service, when called please answer promptly.*
> *IMPORTANT. Under no circumstances should you hang up receiver until through talking, as this will give a disconnecting signal at Central.*
> *Operators are forbidden to visit over the lines. Their exclusive business is to answer calls. Please do not engage them in conversation. It impedes the service and may cause their dismissal.*
> *The use of profane or obscene language over our lines is strictly forbidden.*

LB's PRIMARY SECONDARY SCHOOL

In my mad, headlong rush through life, I am now at the part involving picking up a mess of high schoolers on a regular basis as a carpool parent. Do I own a minivan? Yes. Am I growing increasingly familiar with the hot new sounds enjoyed by today's teens? I am. Does the sheer number of kids pouring out of just one of Long Beach's many high schools at 2:50 p.m. each school day stagger me? I am staggered.

It's amazing that one hundred years ago fewer than twenty kids graduated from the town's sole high school, the aptly and unceremoniously named Long Beach High School.

In 1897, there were five elementary schools in the entire city, with 337 students enrolled, including 58 who were taking secondary-level courses at the various schools. Residents began to feel that the city would grow and that the town would need a high school. Toward that end, a $10,000 bond was passed to pay for a high school and to buy other school sites.

An additional $10,000 was needed, and the Long Beach school board asked for a tax to come up with the funds. Tax? Much of the citizenry was outraged. That was a lot of money just to educate maybe eighty students who were expected to enroll. That amount was lessened somewhat by the

purchase of some cheap land. The Long Beach School District paid $1,520 for the land at the northwest corner of what's now Long Beach Boulevard (then American Avenue) and Eighth Street from Jane and Eli Graves.

The reason for the bargain? The location was out in the sticks. In those days, pretty much everyone lived in the heart of old downtown, near Third Street and Pine Avenue, and on down the coast, not straying more than a couple blocks inland. Eighth Street? There be dragons!

There was heated debate, and the *Long Beach Breakers* newspaper demanded, in a September 25 editorial, "Where are those who shout the loudest?" on the side in favor of the site that was "entirely too far out of town."

The loudest? That'd be Judge H.C. Dillon, a school board member who, as it happened, owned land out of town a piece—close enough to where a new high school would do wonders for land values. The site was approved, but the judge resigned amid conflict-of-interest accusations.

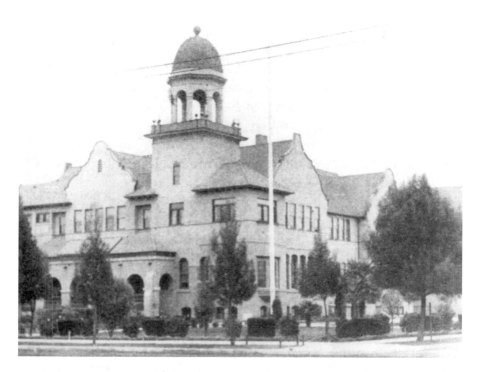

When Long Beach High School, on American Avenue (Long Beach Boulevard) and Eighth Street, was dedicated in May 1898, there was much protest because the site was so far away from the center of town. But at least the land was cheap.

The Mission-style building, with its red tile roof, was dedicated in May 1898 in a ceremony at which Congressman James McLachlan, for reasons that will appear obvious, served as "orator of the evening."

"The public school is, as it has ever been, the safeguard of the country," intoned McLachlan. "Here, the flame of patriotism is kindled in youthful hearts. Here the mists of ignorance and superstition are dispelled by the triumphant light of knowledge."

Long Beach High School was a no-nonsense institution, offering a limited program but one aimed primarily at preparing students for college. Howard L. Lunt was the high school's first principal and his daunting task (modern-day principals can begin sniggering anytime they want) was to not only oversee the entire forty-three-student enrollment but also the entire Long Beach High School teaching staff, which comprised Miss Jane Elizabeth Harnett, history; Miss Louise Callow, Latin; and Elmer E. Hall, mathematics.

In 1897, Ernest Shaul was the first and only graduate of Long Beach High. The 1898 class had five grads; the '99 class had fifteen. It wasn't until 1905 that the number finally exceeded twenty.

Terminal Tropics, the official bulletin of the old Los Angeles Railway, published a story about the new two-story schoolhouse in June 1898: "The architecture of the building is in the mission style, particularly appropriate to the environments of Southern California. It is said to be the handsomest building on the coast."

Forty-three students in the grades nine through twelve braved the trek through the dirt and dust to the school's front door on the first day of classes that fall, and what awaited them inside the classrooms was, compared to today's modern curricula, sheer horror.

In the literary group, there were four years of Latin required. Three years of Greek were also offered, though a student could opt for history instead.

In the science track, students studied civil government, word analysis, zoology, botany and either German or history.

Both courses of study included English, geometry and physics.

Students who chose to study Greek began with the *First Greek Book* and five chapters from Xenophon's *Anabasis*. Juniors studied deeper into *Anabasis* and learned Greek composition. Seniors tackled Homer's *Iliad* along with prose composition and sight-reading.

Mathematics included algebra in the tenth and eleventh grades and plane trigonometry in the twelfth. Elementary geometry was studied by ninth graders, followed by plane geometry in the tenth and eleventh grades. Seniors studied solid geometry.

In a back-to-school story in the school's second year, the *Long Beach Pacific Tribune* newspaper advised:

> *Ninth-grade students in the Latin course should provide themselves with the following books: "Introduction to the Study of American Literature, Irving's "Alhambra," Welsh's "English Composition," Milne's "Elementary Algebra," Collar & Daniels' "First Latin Book," Webster's "Academic Dictionary," Boyer's "Zoology and the National Notebook." Those wishing the scientific course should procure the foregoing, with the exception of Latin, and in its place should procure Tarr's "Physical Geography" and "State Series Civil Government."*

By 1910, things were getting out of hand. On June 24, 1910, eighty-two boys and girls graduated from Long Beach High, making it the largest graduating class in Los Angeles County outside Los Angeles City, the next largest being Pasadena, with seventy-two grads.

Clearly, something was needed to handle the overflow. That something was Long Beach Polytechnic High, which opened in 1911, but that's another story.

When Poly opened, Long Beach High closed and became American Avenue Grammar School, which remained physically unchanged from its high school forerunner's look until it was destroyed by fire during the Christmas holiday in 1918.

The corner was to be forever used for educational purposes, however, despite a further disaster. From the American Avenue school's ashes rose George Washington Junior High, which was destroyed by the 1933 earthquake.

After that, a series of vocational and continuation schools stood at the corner of Long Beach Boulevard and Eighth Street, including, starting in 1966, Will J. Reid High School.

In 2001, a new and progressive school, the Renaissance Career Academy, was built on the corner. Unlike the larger learning institutions in Long Beach, Renaissance emphasizes a smaller, more personalized

By 1910, Long Beach High School's enrollment had grown too huge—eighty-two graduates! To handle the overflow, Long Beach Polytechnic High School, shown here as it was before it was destroyed in the 1933 earthquake, was opened in 1911.

environment for students and faculty. It calls itself a "small high school in an exciting urban setting."

Small? Just like the first school built at that location (give or take four hundred or so students).

Exciting urban setting? That's changed a bit. Suddenly, the old out-of-town site is centrally located and easily accessible to anyone with a minivan.

FLOWER-POWERED GRADS OF 1909 AND '10

Here's our little history lesson for the day: High school graduation these days is different than it was in the olden days. Today's grads, for instance, face an immediate future under the rule of a mess of crooked

politicians, and as for the prospects of one day getting a decent job? They're all taken.

And no sooner do we wrap up our lesson than history itself climbs out of the yellowed clippings of our archives to debunk it.

It turns out—and what could be more shocking?—politicians have been crooked for years, and the good jobs have always been taken, though there has always been room for a better person for the job.

I've been gingerly sifting through the brittle newspapers of 1909 and '10, when the *Long Beach Telegram* cost two cents and covered the graduation with gallons of ink as was appropriate for the biggest school event of the year ("not excepting the Thanksgiving football game")—few folks dared miss the glorious day for the graduates of Long Beach High School, the sole secondary school in the city.

There were sixty-one graduating seniors in 1909, followed by a boom of eighty-two the following year. But while only a few dozen received their diplomas, more than two thousand people made the grad-night trek out to the school on the west side of American Avenue (now Long Beach Boulevard) between Eighth and Ninth Streets (when the school had been built there in 1898, there was much quarreling over the site's distance from the "city," which hadn't extended yet much north of Third Street).

Those who showed were more than just the graduates' immediate, proud families. Graduations in those days were huge events, and the citizenry as a whole was proud of its blossoming adults. Throw away the rest of your June 26, 1909 *Telegram* because as the paper's main story proclaimed in its opening paragraph, "The class of '09 of the Long Beach high school was the only thing of importance last night."

"If there were any people of this city who did not attend the commencement exercises of last evening it was their misfortune brought on through their lack of foresight," the paper's grad-night reporter scolded.

As the thousands clapped impatiently, an orchestra began playing and "the march of the class of '09 started up the middle aisle, girls all in snowy white; boys—well, it doesn't matter about the color of the boys' clothes, for nobody noticed."

The podium was a busy place that evening, with salutatorians, educators, politicians, valedictorians and various performers all offering praise, honors, witticisms and advice. One student mentioned he wanted

to become a physician, and class of '09 president Cleo Zinn fielded the softball by asking, "But is not that profession already overcrowded?"

"Yes," responded his classmate. "But I shall study medicine just the same. Those who are already in the profession must take their chances."

Class orator Clyde Doyle (who would later become one of the young town's most prominent citizens, albeit an attorney), delivered a scathing attack on crooked politicians that was apparently a little too high-handed for our reporter's taste. Our correspondent noted that if politicians could meet Doyle's "lofty" standards, then "we should have no need of politics; the world would be governed by love and charity and peace and honor, and the millennium would have arrived."

The class of 1910, by the *Telegram*'s report, was certainly a florid, showy affair, with the crowd throwing flowers around as if they grew on trees.

The very streets—American Avenue and its tributaries—were strewn with rose petals. Inside, reporter Clara Tunstall took the floral metaphor into full bloom, referring to the grads as the "rose buds of humanity."

Again, there was the parade to the podium, and again lofty oratory was the order of the day (the student body president declared, "Our battle cry is for purity in the social, political and business world!"), but blossoms of the most literal sort marked most of the evening. Girls from the junior class pranced up and down the aisles, over and over, showering the grads with blossoms and petals until, wrote Tunstall,

> *one wondered if the whole of Southern California had been stripped of its choicest blossoms.*
>
> *They laid them at the feet of the graduates and covered their laps with them…and piling them on and spreading them out until the whole beautiful picture was complete, and nothing could be seen but a sea of young faces smiling over borders and hedges and fringes of beautiful blossoms.*

WILSON'S RULES OF '27

I have been, to wildly varying degrees of assiduity, following rules all my life: the Ten Commandments, *Robert's Rules of Order*, the rules of Candy Land and Monopoly and Scrabble, the "Rules & Regulations

Governing Residency" in a certain mobile home park, the Infield Fly Rule, the laws of physics, the laws of nature, the laws of probability, Murphy's Law, the speed limit, the trout-fishing limit, the limit that is the sky.

Oddly, I don't recall many rules back during the two glorious years I spent in the early 1970s at Woodrow Wilson High School in Long Beach.

There sure wasn't any dress code to speak of: the boys wore post–Kent State T-shirts with a target and the word "STUDENT" on the back; girls wore miniskirts with hems that were closer to the wearer's throat than to her knee. You could go wherever you wanted for lunch—McDonalds, Big John's pool hall; you could eat and talk in class. You could lock your esteemed semantics professor out on his own balcony and spend the rest of the period playing Mountain's *Nantucket Sleighride* on the eight-track if you so desired.

OK, you couldn't, technically, smoke, and you had to have some sort of shoes on—the fascists!—but otherwise, things were pretty Montessorian.

In 1927, the boys and girls at the new Wilson High School were given a *Student Handbook* that laid out, over the course of its 145 pages, everything they needed to know to remain in good standing.

Back in 1927, though, when Wilson first threw open its doors to Long Beachers who lived out in the hinterlands (the late local historian Walter Case noted that Wilson's 950 initial students trudged over muddy, unpaved streets), the boys and girls were given a *Student Handbook* that laid out, over the course of its 145 pages, pretty much everything you needed to do to remain a student in good standing at Long Beach's second high school.

Homeroom, for most latter-day students, is pretty much a staging area: a place to catch up on homework and gossip and listen to the litany of announcements from the principal's office. It was a weightier place in 1927, according to the handbook, which informed students that homeroom "is a forum for a discussion of student problems and activities and develops ideals, right attitudes and intelligent citizenship, essential for a democracy."

There was a manners clause in the handbook, an important issue in that era in which manners were

> *the outward manifestations of a well bred lady or gentleman. Woodrow Wilson students know that a quiet voice and a dignified bearing nowhere else mark so quickly the lady or gentleman as on the streets or other public places…They will try to act in public places and in school as well bred ladies and gentlemen should act.*

One of my favorite rules of '27 was in regard to handling the curtains in the auditorium. Wilson was proud of its curtains; didn't want anyone messing with the curtains.

"Hands off curtains," demanded the framers of the handbook.

> *Because:*
> *a. Any movement of the curtains is distracting to the audience.*
> *b. Handling soils the curtains.*
> *c. Don't make this a hick school—Restrain your desire to peek through the curtain. The tiniest peek is painfully visible from the front.*

The lunchroom was no place for horseplay, either.

In the lunchroom, the student was to act the same as he would "in a café or cafeteria down town." The student was urged to speak in modulated

tones, clean up after himself, push his chair in when finished and, most importantly, "[remember] that the faculty line is not open to students."

Was there a dress code for boys? Not that I could find in the handbook.

Was there a dress code for girls? Of course. Did we want Wilson turning out tramps? A female student was required to wear a white cotton middy with a blue detachable collar, a dark blue wool pleated skirt (knife, box or side pleats only, please), black sailor ties (recommended) and low or Cuban heel shoes.

The courses, of course, were strictly no-nonsense. School went from 8:00 a.m. until 2:55 p.m., and the boy whose handbook fell into our lap almost seventy-five years later took World History, Latin II, Physical Education, English IIa, Geometry Ia and Commercial Law.

Above all, each student was urged to sign a pledge at the front of the handbook, to honor Wilson's traditions, to "observe her laws and do all I can to promote her future welfare. I will never consciously do anything that would bring reproach to her good name, to the student body or to the faculty."

WHEN YOU COULDN'T CANCAN

Without laws there is anarchy, and Long Beach was never big on anarchy, so it passed laws.

For instance, a law in 1908 might not have prevented anarchy, but it put a dent in the cancan by prohibiting any dancing of "the hula hula, kan kan, the Pedro Bowery dance or any imitation of such dances." Even the more sedate of your dances—your waltz, your one-step—had to be danced by the bright light of day, or near day, as the anti–dance fever ordinance also insisted that "electric lights or gas jets as powerful as 16 candles" had to be provided for each ten square feet of dancing space.

A decade later, things hadn't softened up. In 1918, on the brink of the Roaring Twenties, Long Beach made it illegal for a man to kiss his wife goodbye at a train depot or for a girl to put her bothersome brother in a half nelson at the park.

"No person," stated the ordinance enacted on May 14, 1918,

shall indulge in caressing, hugging, fondling, embracing, spooning, kissing or wrestling with any person or persons of the opposite sex in,

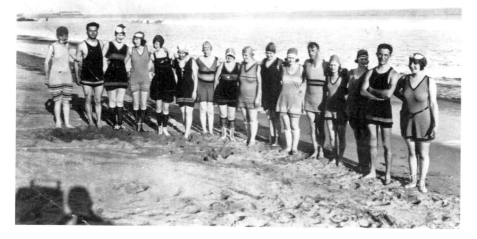

These beachgoers in their scanty and revealing swimsuits are testing the limits of the 1920 ordinance regarding apparel worn in public.

upon or near any public park, avenue, street, court, way, alley or place, on the beach or any other public place in the City of Long Beach.

That ordinance was just one of the many on the books in the early days of the city that showed the town's love affair with puritanism and prudery.

There were laws, for instance, that mandated, practically to the inch and hue, what manner of clothing should be worn at the beach.

See if you can follow along with this 1920 ordinance:

No person over the age of 6 shall appear on any highway or public place or on the sand or beach or in the Pacific Ocean in Long Beach clothed in a bathing suit which does not completely conceal from view all that portion of the trunk of the body of such person below a line around the body even with the upper part of the arm pits, except a circular hole for each arm, with the maximum diameter not longer than twice the distance from the upper part of the arm pit to the top of the shoulder, and which does not completely conceal from each view each leg from the hip joint to a line around the leg one-third

of the way to the knee joint, and without such bathing suit having attached a skirt made of opaque material completely surrounding the person and hanging loosely from the waistline to the bottom of such suit.

Long Beach's policemen enforced the laws enthusiastically—and the chief was as active in earning collars as any beat cop in those days.

Chief C.E. Moyer, who ran the department in 1911, was an avid pursuer of justice as regards felonious fashion.

As a result of complaints received from a couple of prudish citizens in February 1911 that some of the showgirls in the theaters at the Pike were a tad overly underdressed, the chief spent a Thursday and Friday evening visiting some of the allegedly offensive showplaces. According to a newspaper account, Moyer made discoveries that "horrified" and "dazed" city lawmen.

Rules ensued. Among those declared by the chief was the matter of tights.

"Tights (as sole apparel) are simply and positively forbidden. Choruses may wear pants, hoopskirts or barrels over tights," he told proprietors. "But they must be covered with something besides atmosphere and opera glasses."

Chief Moyer next turned his baleful eye to the beach. His intent, he declared, was "to make the beach pure and wholesome in every respect...Nothing immodest or suggestive will be tolerated. Furthermore," he added, "it is probable that the parading in the streets in the abbreviated costumes worn by some bathers will also come under the ban." And objectionable postcards, too, were to go, as well as offensive views displayed in "the cheap nickelodeons."

Less racy issues of concern to early Long Beach lawmakers had to do with the newfangled automobiles that started to sputter into town at the dawn of the twentieth century. In the earliest days, speeding was whatever John Law said it was. The first laws on the books merely declared it unlawful to "ride or drive a horse or other animal, or propel a bicycle, tricycle or other vehicle on any street in the city at an immoderate or dangerous rate of speed."

Said immoderate or dangerous rate was, in 1915, determined to be "one mile in three minutes" outside town, while the area between Pine and Alamitos Avenues south of Seventh Street was designated as

a "congested area" in which the speed limit was "a mile in not less than four minutes."

Apparently, you had to do the math yourself.

And you had to have a head for geometry as well to obey the early parking laws. The city's first law regarding parking was enacted in 1912, and it declared that a vehicle must be backed to the curb "at a true right angle" with both wheels touching the curb. "Attached animals," said the law, were then to be parked at right angles to the vehicle.

In 1919, with animals pretty much out of the picture, the law was amended, and automobiles were allowed to park at forty-five-degree angles to the curb.

Earlier in town, during its first days, back before sex was invented, the crime logs were a bit quainter. The young city's first marshal, H.A. Davies, recalled in an interview decades later that "gangsters and banditry were unknown in the late 1880s. Once in a while I would encounter a citizen who may have taken a bit too much liquor aboard and I would take him home."

One of the first crimes in town that required detective work by Davies involved the liberation of seventeen impounded dogs. Davies, who also served as the city's tax collector and dogcatcher, told his interviewer, "We had lots of stray dogs in those days." Because his myriad duties didn't allow him to run around after dogs all day, he acquired the services of

The automobile brought innumerable changes to Long Beach, including the electrically operated traffic signal, the first of which was put into commission in 1927 at the intersection of Broadway and Pine Avenues.

two boys in town. He paid them a dime a dog, not bad money at the time. "I had seventeen dogs in the pound [near the town's first jail built in a hollow on First Street between Pine and Locust Avenues] at one time and at night they became rather noisy."

Under cover of night—there were not streetlights in those days—someone came and pried off some of the boards of the fence and sent the dogs back into their romping freedom.

"I was quite upset the next morning," said Davies, "and I decided to do some detecting.

He was getting into his coat when a Mrs. Snell came in. "I told her I was pretty busy having to detect the person who released the 17 dogs. She said I need look no further, as she had let them out.

"She wasn't a bit ashamed," said Davies. "And I confess to feeling a bit sheepish over her frank confession. She told me what she thought of letting 17 dogs howl all night, and we let it go at that."

Lookin' Good, Long Beach

In the summer of 1884, the real estate firm of Pomeroy & Mills bought the site of Willmore City for $240,000, marking the end of William E. Willmore's hopes for himself and his city.

A syndicate of businessmen and property holders was formed, and one of the first orders of business was to name the town. Choices were scribbled onto paper and tossed into a hat. The choice of Long Beach was the overwhelming favorite; Crescent City was a distant second.

Another order of business was to draw up some plans and rules for the town, which, the new owners were sure, would grow up quickly.

If you bought a parcel of land in the new Long Beach in 1884, you would want to read the rules carefully and plan to adhere to them.

In its preamble, the city's planners wrote:

> *It is highly desirable that some plan uniform in its general points should be adopted by all persons purchasing and improving property in Long Beach. To this end, the managers have, after consultations with many persons, formulated the following plan and rules, with which a hearty cooperation is requested in order that Long Beach may become a thing of beauty and pleasure.*

1. All buildings are to be set back from the front of the lots at least 30 feet, as stated in the original deed to the purchaser. This will prevent anyone from building out to the front and obstructing the view of others who have built back from the front.

2. A palm tree should be planted in the front of each 25-foot lot, seven feet back from the front of the lot, or in line with any palms already planted. If this is done it will give a very pleasing and fine appearance to the whole city and will add materially to the value of the property.

3. A eucalyptus tree should be planted on the edge of the sidewalk opposite each 25-foot lot, and a hedge of evergreen plants should mark at least the front of each lot.

4. Each person should level off the sidewalk in front of his lot and keep it clean and in good condition.

5. Water-closets should be set at least five feet from the alleyways in rear of the lot.

6. All stock must be kept by the owner on his own premises. No stock will, under and circumstances, be allowed to roam at large, as it will do much damage to the shrubbery and trees. Where damage is done by stock the owners must promptly pay to repair the damage.

7. Water will be furnished free to a reasonable extent for use on lawns, shrubbery and trees for at least until January 1ˢᵗ, 1885. Those planting prior to that date will also be allowed for same use free water for one year longer, to January 1ˢᵗ, 1886.

8. Campers for 1884 will be allowed to camp, with permission of the Company's agent, along the line of the bluff east of Locust Avenue and south of Ocean Avenue, but all their stock must be kept safely tied up at the place designated by the Company's agent. Campers will be charged only for the use of water, as follows:
a. For each tent of three persons or under, 50 cents per week or part of a week; over three persons, 75 cents per week.
b. For each animal, 15 cents per week or part of a week.
c. Other uses to be charged at a reasonable rate.
d. All water charges must be paid for in advance and the Company's receipt obtained therefor.
9. No objectionable or inappropriate bathing suits will be allowed under any circumstances, and all attempts to use such will be promptly punished under Criminal Laws of this State.

Even before the advent of the automobile, parking was a problem in Long Beach. People venturing into town, or even just camping on the beach, parked their horses and wagons on the strand in 1884.

10. No conveyances or teams of animals will be allowed to occupy the streets of Ocean Avenue or the beach or permanent camping or stopping purposes west of Locust Avenue.

CARS HIT THE STREETS

Long Beach wasn't even old enough in 1902 to apply for a driver's license when E.R. Brown's car wheezed down the road, scattering children and making horses bolt in wide-eyed terror.

Brown, a Pine Avenue jeweler and early bandleader, was one of the first car owners in the fourteen-year-old village. It took him and his son two years to build the steam-powered vehicle, and it was the talk of the town as amazed strollers watched the Brown boys speed up and down Pine Avenue—at top speeds of fifteen miles per hour.

By year's end, the Long Beach automobile fleet would grow to three. Harry Hamilton, a real estate broker, was the next to move into the future with this ultimate toy. He bought a White Steamer in 1902. Another local

man, William Varney, who would later go into the car repair business, also bought a car—a Stanhope Steamer—that year.

Naturally, it wasn't long before everyone had to have one. The early car owners were the big shots in town, and most of them purchased the hugely successful Ford automobiles. Early in 1904, a record of thirty-one car sales was made by the first Ford Agency in Long Beach. Bank owners and civic leaders snatched the cars up: C.J. Walker, P.E. Hatch, Charles Heartwell and C.J. Daugherty.

By 1907, only five years after the first trio of steamers had rattled down the Long Beach boulevards, a count showed that there were between four and five hundred automobiles in Long Beach.

And there were six garages caring for the hundreds of Long Beach automobiles, which, according to one chronicler of the era, "every day or less have something the matter with them."

With the advent of the auto came laws restricting their speed in town. The first speed limits set twenty miles per hour as the fastest anyone was allowed to travel anywhere. In the so-called congested district, between Maine and Alamitos Avenues and south of Seventh Street, the limit was fifteen milers per hour and ten miles per hour when "passing a school, approaching an intersection and going around a corner or curve."

As always, laws had to be passed to prevent the actions of dense drivers. Enough people left their cars unattended on railroad tracks that a law had to be passed barring that.

A "visible or audible" signal was required when making a turn. The signal could be made by holding out a hand or by "one blast of the horn."

It was also unlawful to drive between one hour after sunset and one hour before sunrise without a lamp showing white light toward the front and red toward the rear.

Inevitably, fender benders came to Long Beach. For the most part, the scattered drivers managed to avoid one another, but with increased traffic around Christmastime in 1905, P.E. Hatch, then cashier of the National Bank of Long Beach, was involved in an accident with Jotham Bixby Jr., son of the president of the same bank.

Hatch was driving a Rambler touring car, and Jotham was driving a team of mules harnessed to a light buggy when the collision occurred on Magnolia Avenue.

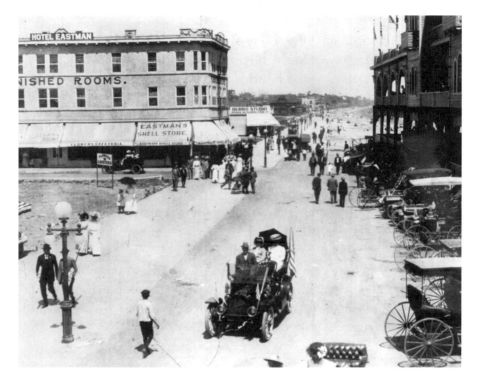

In the opening years of the twentieth century, automobiles began making an appearance in Long Beach. Here, a family and their new ride are attracting attention as they motor along the seaside shops, passing parked wagons and coaches.

"Fortunately," according to the account, "the occupants of the outfits were not injured, though the auto was badly dented from the force of the collision and two of the lamps were broken. Considerable of the paint was knocked off the Bixby buggy and some of the woodwork was broken."

STREET NAMES

If you get lost driving around Long Beach, don't blame the city fathers. The original, and even early subsequent layouts of the town, made getting around a no-brainer, even if it was a little rough navigating the wagon-rutted roads of late nineteenth-century Long Beach. There was no way to get lost in the town the way it was laid out as the American Colony—a much more likably pompous name than the

somewhat plain, if fetching, Long Beach that it quickly became. You had Ocean Park (now Ocean Boulevard) running along the coast as the city's southernmost road and the street from which north–south house address numbers originated.

Moving north, you had the east–west streets named First Street, Second Street, Third Street—you see what the planners were doing here?—all the way to Tenth Street, after which you were at the end of the road, road-wise.

American Colony founder William Willmore gave sort of generic names to what he planned as the major east–west streets—Pacific, American (now Long Beach Boulevard) and Atlantic Avenues—and he seeded the smaller avenues with arboreal names. Magnolia was the western boundary, and interspersed eastward were (and still are) Chestnut, Cedar, Pine, Locust, Elm and Linden Avenues. That would pretty much get you to the end of town, which was Alamitos Avenue, the boundary line between the two ranchos that would make up the bulk of Long Beach.

So, there you go. What could go wrong?

And things were just as simple once you crossed Alamitos and ventured into the Alamitos Beach town site, where organizers had thoughtfully laid out the streets in a nice, alphabetical section. As long as you knew your ABCs, you didn't need a GPS: Bonito, Cerritos, Descanso, Esperanza, Falcon, Gaviota, Hermosa, Independencia, Junipero, Kalamazoo, Lindero, Modjeska, Naranja, Ojai, Paloma, Quito, Redondo, Sobrante and Termino, which was the eastern boundary of Alamitos Beach—and all was well in the world.

But the Alamitos Beachers didn't see the day when new streets would be added in between the alphabetical streets, throwing everything out of whack, and many of the street names were changed for no good reason that we can see from this remove.

Some changes were fairly nonsensical. Termino, for instance, became Euclid, and a new Termino was added three blocks to the east as the township expanded—ostensibly because Termino was the terminus of the town, though it hasn't retained that position in the intervening years. Naranja, which is Spanish for "orange," became Temple, after one of the early landowners of the area that would encompass Long Beach. Descanso, meanwhile, became Orange Avenue.

The following are other early changes of the alphabetical streets: the glorious Independencia became Cherry, Sobrante became Loma, Modjeska turned into Molino, Kawahea became Kennebec, Ojai was changed to Orizaba and Quito became Coronado. It was a good time to be a street sign salesman.

In this era, two of Long Beach's most problematic street names came into being with Ximeno and Junipero Avenues.

Junipero's namesake was the Johnny Appleseed of missions, Father Junipero Serra. Therefore, ideally, it should be pronounced "Yoo-nee-PER-oh," with the absence of any stress indicators. Ximeno is the masculine form of Ximena, who was the wife of Spanish nobleman El Cid. There shouldn't be a street named Ximeno in the first place, but given that there is, the Spanish pronunciation would be, generally speaking, "Hee-MAY-no."

That said, they're not typically pronounced that way. In the grand tradition of U.S. citizens pronouncing things the way they want to pronounce them (see: San PEE-dro), the pronunciation of Junipero has fairly fully fallen into Yuan-IH-pero, despite the clear absence of the letter A. And Ximeno is almost unanimously pronounced ex-IM-eno. One pronounces them correctly, in the Spanish manner, at the peril of being labeled some kind of fancy-pants snob.

Eastward again, Belmont Shore's developers came up with a raft of names that bring to mind places we don't want to live. Trying to establish

Any way you say it, the missionary Junipero Serra is the namesake of one of Long Beach's most mispronounced streets.

itself as an oasis of sorts, a place for inlanders to come and cool off, perchance to purchase one of the shore's seaside cottages in the era long before McMansions, several of the streets were named for towns whose residents might most appreciate the cooler and breezier climate: Corona, Covina, Claremont, Glendora, Covina and Santa Ana.

Then came the boomiest of all expansions as the city pushed eastward again and way up to the north with the postwar building explosion that added the sugar beet and bean fields to the city limits with the 1950s development of the Plaza and Los Altos areas. Once again, builders took a stab at alphabetizing north–south avenues for directional cues, even though the building of normal grids had fallen from favor and twisty and winding roads sometimes crossed one another or vaulted over others. Still, at least they tried, with an alphabet that started with *H* and ran through *P*. The streets are still named the same today, with no theme whatsoever other than the alphabet: Hackett, Iroquois, Josie, Knoxville, Ladoga, Monogram, Nipomo, Ostrom, Petaluma.

There were seemingly more streets than names for them in those building boom years from 1950 to '60. Developer Lloyd Whaley named Britton Drive as a reward/payment to then popular actress Barbara Britton's visit to the development as a pitchperson for the new, modern homes in the neighborhood behind the Los Altos Shopping Center.

For general navigating purposes, Pine Avenue continues to divide the town east and west until it gets all tangled up in the Los Cerritos area at Country Club Drive, after which Long Beach Boulevard is where the 100 East and 100 West blocks originate. Ocean Boulevard divides the city, however inequitably, north and south.

As you walk, bike, bus or drive inland, the numbered streets will sort of help you out, but they grow hazy past the original northern boundary of Tenth Street.

Eleventh Street plays a pretty minor role, and none of the other double-digit numbered streets manage to make it from one end of town to the other. The major east–west streets have all lost their numbered designations, if they ever had them. Thirteenth Street has never existed, for weak but obvious reasons. It goes by the name of Anaheim Street. Pacific Coast Highway would be Eighteenth Street; Hill Street would be Twenty-second; Burnett would be Twenty-fourth; Willow would be Twenty-sixth; Spring, Thirtieth; Wardlow Road, mostly Thirty-fourth;

Carson, Forty-first; Del Amo, Fiftieth; Artesia, Sixty-sixth; and you hit the end of the numbered streets at Seventy-second. (Coincidentally, the end of Long Beach's tony Peninsula is Seventy-second Place.)

As nature intended, even-numbered addresses are on the south or east sides of the streets.

Finally, for those who want to figure out distances without stooping to Google Maps, the main avenues—running north–south—are one-quarter mile apart. The major streets—running east–west—are about one-half mile apart.

MAP OF THE TWENTIES

Belmont Shoreite reader and occasional correspondent Stan Fosholdt, whose interest in the old days of Long Beach was rekindled by our recent columns about Long Beach street names, sent us a map of a particular time in Long Beach—the late 1920s—when the forty-year-old city had already grown into a fairly large town but was still on the brink of some huge expansion, both in terms of real estate and magnificent projects.

Many of the best things in Long Beach that have since been torn down hadn't even been built yet in 1928, as the map reflects.

It shows the Pine Avenue Pier that started at Ocean Boulevard and spanned Seaside Boulevard before shooting out over the still-wild breakers.

The map shows the area of the "proposed auditorium [and] pleasure pier." The pier, which would come to be known as Rainbow Pier, would, at its opening in the summer of 1931, incorporate the Pine Pier at its west end and then arc out and over to Linden Avenue, allowing for a beautiful Sunday stroll or car ride. The auditorium, finished the following year, was the glorious Municipal Auditorium, site of thousands of conventions, pageants and concerts over its four-plus decades of existence—way too short a tenure for such a palace.

The pier would eventually be filled in to make a footing for today's Convention and Entertainment Center and the Long Beach Arena.

Out in the harbor land, the map shows the site of the 1928 Pacific Southwest Exposition, a world's fair–style expo that drew a million people to see the cultures of far-flung and then mysterious lands. Across the

From its opening in 1931 until its demolition in 1966, the Rainbow Pier, arcing out 1,350 feet into the Pacific and running from Pine to Linden, was the signature structure of the city.

channel and west of the expo grounds, the map shows the Ford Motor Company's Long Beach assembly plant, built in the late 1920s to expand production of Ford's Model A, which replaced the Model T in 1927. The plant closed in 1958.

The Eastward Ho! expansion was still crawling slowly in that direction in the late '20s. Naples and Belmont Shore had been recently tamed, though some street names were a bit different—and the peninsula was a tad longer, going to Seventy-fourth Place, a couple of blocks past today's Seventy-second Place terminus.

And the today's peninsula's "Main Street," Sixty-second Place, was called Pier Avenue, despite the lack of a noticeable pier. Park Avenue in the shore, as we've noted recently, was called Santa Fe then, and Glendora was called Artesia Avenue.

The eastern boundary on the south side of town was Manila Avenue, in Alamitos Heights, just north of what, in a couple years, would be called Marine Stadium, but on the '28 map it was called Recreation Park Lagoon.

The Columns

The eastern boundary north of Manila was Hathaway Avenue, named for the Hathaway sisters, several of whom married various men of the Bixby family in the earliest years of the city. Hathaway was, in fact, a continuation of Pacific Coast Highway. Its name became State Street at Bennett Avenue and kept that name up to the western boundary of town (though it didn't span the Los Angeles River. The only bridges across the creek in those days were at Ocean Boulevard and Anaheim and Willow Streets).

Nothing converged on the Traffic Circle in 1928 because there was no Traffic Circle yet—that would come in four years. There was no Lakewood Boulevard or Los Coyotes Diagonal here yet. There was a bit of a circular drive—more football-shaped, really—in the area called Alamitos Boulevard (a couple miles from Alamitos Avenue), which could be entered from State and Twentieth Streets and Grand, Loma and Redondo Avenues. Looks like a deathtrap to us.

Stearns Street, one of the key boulevards of the distant-future Los Altos area, was, in 1928, for its entire three-block length from Bennett to Loma, a bit of the eastern boundary of town before Newport took over that role along the eastern slope of Signal Hill to the airport, where few people lived, because who would want to live by an airport?

Where people wanted to live, as ever, was near the water, and one of the more striking things about the old map is how far back we've pushed the Pacific Ocean.

From our sprawling suite of offices in the ARCO building, we can look down and see Seaside Way (downgraded, considerably, from its more glorious days as Seaside Boulevard). In 1928, a visit to Seaside Boulevard was the end of the road for this continent. Walk south from there and your feet would be wet in seconds.

Nowadays, you need to wear comfortable shoes and pack a lunch to go from the now-misnamed Seaside to the sea. It begins with a perilous crossing of the Grand Prix track that is Shoreline Drive, a crawl through the Aquarium of the Pacific's parking structure, then through or around the aquarium itself, across a park and finally to the sea and its no-longer-wild waves.

Electric Ladyland

It's remarkable that the first power plant in Long Beach was built and operated by a woman, and this was back in 1895, when women simply didn't go around creating and operating power plants.

An 1898 publication called *Greater Los Angeles* even went out on a limb that year in saying that the plant, opened by Iva E. Tutt in the spring of 1895, was "the first electric light plant in the United States and probably the world to be installed and managed by a woman."

The plant was built at 26 Tribune Court (an alley extending north from Ocean Boulevard between Pine and Locust Avenues) and was put into operation on July 25, 1895, when Long Beach was a town of about one thousand.

In the fall of the same year, Tutt applied for and obtained a similar franchise in San Pedro, and in April 1896, that town was hooked up to the Long Beach station.

Thanks to the Tutt plant, all of Long Beach was lighted up, as well as San Pedro and Terminal Island, where a long line of electric lamps was maintained on the beachfront.

Although we've been unable to dig up a photo of Tutt, Long Beach historian Claudine Burnett said she was described in the media as being an extremely beautiful woman, "making it even more amazing to the mind-set of the time that she should choose such a career." Those mind-setters might have noted that she was married and had a daughter, Margaret.

In a 1903 interview with the *Los Angeles Herald*, Tutt related how her father had been a steamboat man on the Mississippi, and he used to take her along and show her all the machinery.

Tutt got a charge out of the business of power generating and told a reporter that instead of reading fairy tales, she read the engineering reviews and scientific papers her father subscribed to.

She married Edward Stanley Tutt, a Montana rancher, and the couple moved to Los Angeles, where they discovered that Long Beach could use an electricity plant.

Iva Tutt put the plant together and then looked for a superintendent but could find no one better qualified than herself. In fact, she became president, secretary, treasurer and general manager of the company.

In 1899, she sold the Long Beach & San Pedro Electrical Company to a company that would, a few years later, sell to Southern California Edison, which built a substation at the site.

As long as we were in a utility bills–paying mode, we decided to check up on the roots of the Long Beach Gas Co., as well. We discovered that a group was formed in July 1900 to build a gas plant in town. And this group was going to build a gas plant pretty much regardless of whether people wanted a gas plant or not. Other people's opinions weren't given a lot of weight back in those years when, by God, men (our Ms. Tutt notwithstanding) knew how to get things done.

"Plans are complete to go right ahead and give Long Beach [gas] service," reported the *Pasadena Star* newspaper in July 1900. "There is confidence that Long Beach offers a first-class opportunity for developing a gas business. Beach towns are noted for their liberal consumption of gas, and Long Beach has grown very rapidly."

A few days later, Long Beach Gas Co. director Thaddeus Lowe issued a statement to the press: "You may assure your readers we have come here for the purpose of putting in a gas plant and that we are going to do it, no matter what oppositions there may be."

End of discussion.

Water for Long Beach

Years before the population hit one hundred, and before the city got its name, water was fairly scarce in Long Beach, trickling into what passed for a town in 1881 as a creek running from three artesian wells drilled on Rancho Los Cerritos for livestock and ranch workers. As people, too, began trickling into town, a concrete reservoir was built to hold the water before it ran into the sea.

As the population grew, water became a business. Wells were drilled in the Lincoln and Recreation Park areas. More famously, in 1895, a well-driller named J.B. Proctor struck water below land that was planned for a town site by retired Union army general Edward Bouton. Proctor's second attempt to hit water succeeded to such an extent that the land Bouton envisioned for a city became, instead, a lake—one that's still used, in a tamed and abbreviated form, as a hazard for wayward duffers at Lakewood Country Club.

Bouton learned that when God gives you water, you make…well, you make money with it. He began peddling his water from the lake—which would become the rather bland namesake for Lakewood—to outlying areas, delivering it by pipeline to the land near what's now around the intersection of Orange Avenue and Twenty-eighth Street, as well as, by 1897, much of Long Beach proper, via a four-inch pipeline taking water from Tenth to First Street.

In the summer of 1911, with Long Beach having become a full-fledged city of eighteen thousand, the Long Beach Water Department was formed when the city bought out Bouton and another private water company for $850,000.

In the earliest days of water usage in Long Beach, the rates were fairly standard. For instance: "For every dwelling house of three rooms or less, including bath and toilet, occupied by one family, 75 cents per month."

If you had more stuff, it cost more money. For each horse kept for private use, for instance, you paid a dime per month, which included water for washing the carriage. For each cow you owned, you paid the water company a nickel each month.

Oil! Or, water, anyhow. Water was more valuable, anyway, in the days before the auto to sustain a growing city and its outlying agriculture. Early users paid seventy-five cents a month per household for water.

Human population growth far outstripped that of cows and horses, and water demand increased dramatically. In 1921, the city's population was 56,000; less than a decade later, it had almost tripled to 142,000.

The problem was studied by some of the city's greatest men: Frank F. Merriam, C.A. Buffum, Charles L. Heartwell, C.J. Walker and others. They made a couple of key recommendations: that the city acquire a strip of land—a 350-acre parcel bordered by Carson and Parkcrest Streets and Lakewood Boulevard and the San Gabriel River—to be used for new water wells and to form a board of water commissioners to manage the department without outside political interference.

Voters approved the creation of the board in 1931 and, in the same election, authorized membership of Long Beach in the Metropolitan Water District, from which the city today receives about 50 percent of its water by way of the Colorado River.

Also in 1931, the strip of land that would later become Heartwell Park (after water commissioner Charles Heartwell) was purchased for $711,000.

All of those moves were key to Long Beach's survival, as were later advances by the Long Beach Water Department, including improved drilling methods and other new sources of water; innovative methods of water conservation; and the continuing work in water reclamation—the department even has its own line of bottled water.

As for the future, there's the continuing work being done in desalination and, more visibly, the continued digging up of city streets. Of Long Beach's 902 miles of water mains, more than a third—333 miles—were installed between 1918 and 1939. They're being replaced at a fairly brisk clip—about sixty thousand feet per year. It should be all finished sometime in the 2020s.

A MODEL A TOWN

Sometimes in the course of writing our weekly column about Long Beach's past, all we can do is serve as typists, channelers for reporters who have long since ceased banging at the keys.

For instance, seventy-three years ago this month, the Ford Motor Company threw a grand opening for its Long Beach assembly plant,

where crews had already been working for a couple of weeks churning out the company's popular Model A.

We could attempt to describe the plant, embellishing on the arid press release turned out by Ford:

> *The Long Beach Ford plant is located on Henry Ford Avenue on the north side of the Cerritos channel, north of Terminal Island...The plant was completed and production of automobiles began March, 1930. A grand opening and public showing was held in April, approximately a month after production had started.*

Better to just start typing, swiping word for word the unmatchable, Swiftian prose of reporter Nan Blake, whose description of the plant in the April 21, 1930 *Press-Telegram* is almost deafening in its descriptiveness.

It begins beneath the headline "GIANT OBEDIENT TO WILL OF PYGMIES":

> *A mammoth power giant, shackled, obedient to the touch of man, but registering its tremendous force in every slow, undulating movement of its Brobdingagian body, has been born in Long Beach. Its colossal maw is fed with the raw products of the earth that in turn have been ground, smelted and molded to man's use by other fettered powerful Herculeses. Its attendants are goggled, sweating pygmies; Lilliputian servants of their pinioned Goliath, yet controlling it by the triumph of intelligence over matter.*

(Nowadays, a reporter—certainly a columnist—would pretty much take the rest of the day off at this point. That first paragraph's about a week's worth of writing in terms of calories spent. And yet, she goes on, like a...well, we're not going to get into an analogy battle with Ms. Blake.)

> *To the casual eye it is a commercial brute that fashions products for material gain, but beneath the deafening hum of wheels and the crash of leviathan machinery is a counter-harmony composed of the song of birds; the rustle of soft winds in the trees; the sound of crystal streams bubbling over shining pebbles; the roar of waterfalls down mountain sides, all blended in a great paean to the Open Trail.*

The Columns

To the man or woman with no imagination, the new Ford Motor plant in the harbor district will be nothing but mass production at its zenith. But to one blessed with the gift to dream, freedom, sunshine and an unexplored world will be fused with the chilled steel and hammered home with each blow of the riveters.

Blake leaves us now on our own to fill in the intervening years since Ford's opening.

By 1931, the plant had 1,700 employees working three shifts and turning out three hundred Model As a day.

The next decade and a half were full of erratic years for the plant. It closed in December 1932, when it became difficult to obtain parts for production, and then remained closed for another several months after damages suffered during the March 10, 1933 earthquake. It went back into production in December 1934 but closed again during World War II, when the U.S. government dragooned the plant for use as an army supply depot.

The plant was enlarged in 1950, and soon the place was as noisy and as Brobdingagian as it was in the days of our Nan Blake. That year was Ford's peak year as it put out 72,316 cars and trucks. By '52, the Long Beach facility, since the close of World War II, had assembled and released more than 325,000 vehicles.

It survived other parts shortages, managed its way through labor strikes and outlasted fires and an explosion, but the plant eventually outlived its usefulness to Ford. It closed a lot more quietly than it opened, with its last vehicle, a 1959 Fairlaine, driving off the lot in March 1959.

The building itself wheezed along for several more years, mostly serving as a warehouse, though enjoying a few bursts of fame serving as a set for such films as *RoboCop* and *Lethal Weapon*. It was finally razed—released from its shackles, if you will—in 1990.

A CENTURY OF SCENERY

A city park turning one hundred years old, as Bixby Park did in 2003, especially one with an ocean view, seems an impossibility in a town where ocean views are gobbled up by developers (frequently with no clear idea

of what it is they want to develop; they just want to develop something, and they figure that whatever it is would work best with an ocean view). There have been plenty of such parks that have disappeared altogether beneath buildings or been carved up into tiny parcels serving as little more than front lawns for office buildings or landscaping for civic centers.

Long Beach's Santa Cruz, Palm Beach, Victory and Lincoln Parks have all disappeared or significantly dwindled.

But Bixby Park has lived on, fairly unscathed through Long Beach's boom years, its troubled years, its redeveloping years, since the time when it was known as Alamitos Park, way east of the then city limits, when it was just a parcel of vacant land surrounded by other parcels of vacant land.

In the late 1880s, when Long Beach was still in short pants and stood several miles from the Bixby family's ranch house in Los Alamitos, Mary Hathaway (one of the many Hathaway relatives of the pioneering Bixby family; five Hathaway women married Bixby men) was invited by her brother-in-law John W. Bixby to accompany him on a wagon ride from

Alamitos Park became Bixby Park when the Bixby family's Alamitos Land Company deeded it to Long Beach on September 28, 1903. It soon became the centerpiece of Long Beach as the city expanded eastward down the coast.

the rancho to the young city. Decades later, Hathaway recalled the ride in an interview with the *Press-Telegram*.

"The day dawned under a heavy fog," she recalled.

> *In driving along we passed one lone sheepherder who, with the assistance of his dogs, was moving a thousand sheep from one camp to another. There was not a tree between the ranch house of Los Alamitos and Long Beach.*
>
> *Eventually, my brother-in-law drew rein at the present site of Bixby Park and whistled shrilly. At once, the shadowy outlines of a man's figure appeared through the fog's thick veil and a man emerged who was introduced to me as "Mr. Messick," superintendent of Alamitos Park, future center of the great city of Long Beach.*

Hathaway remembered Bixby and Messick unloading some shovels, spades and other gardening tools, as well as some canvas-covered plants from Bixby's wagon, before resuming the trip into Long Beach.

Years later, Hathaway would wonder, "When I walk under the cypresses, the tall eucalyptus trees and a few ancient peppers that give an air of age and dignity to Bixby Park, whether any of those old trees may have been among those bundles."

Whatever it was, most of Alamitos Park was planted in 1890, and the lots around it went up for sale. You're too young to kick yourself, but you might want to have a stern word with your forebears for not reacting quickly to an advertisement in 1902 that offered lots between Broadway and Third Street and Obispo and Temple Avenues. We're going to be using the figure of sixty dollars; it will not be a typo: "Level lots, 25x150 feet, with good view of the ocean, no city taxes, trees planted on all streets, and water piped to lots with no extra charge. Prices $60 and up, $10 down, $10 per month without interest."

The park, which would come to be called Bixby Park when it was deeded to Long Beach by the Bixbys' Alamitos Land Company on September 28, 1903, became the centerpiece of Long Beach as the city expanded eastward down the coast.

The park was kept colorful and shady thanks to the work of full-time expert gardeners. In earlier days, there was a goldfish pond decorated with water lilies, a large aviary containing many species of birds and even some cages of monkeys.

On through the 1950s and '60s, when Long Beach was still largely made up of relocated midwesterners, Bixby Park was an annual gathering spot for fellow "statespeople" to gather for picnics. The largest, of course, was the Iowa picnic, which would bring as many as 100,000 Hawkeyes to Bixby Park. Residents of Illinois, Kansas and Minnesota also held annual picnics at the park, bringing in numbers between 10,000 and 15,000.

In the late '60s, a fountain was installed at the park, lighted beautifully at night, but vandalism caused its closure in just a few short years.

Vandalism, in fact, was all the rage in those days—and it still remains in vogue today—which is why, while Bixby Park is still lush with greenery, most of the colorful flowers have been trounced on too frequently to warrant replanting.

In the '80s, even more problems plagued the park as it became a gathering place, not for old-timers playing roque or canasta, but rather for a younger crowd using the grounds for prostitution, drug use and sales and public sexual activity.

Measures were taken to counter the problems: the park closed at 10:00 p.m. instead of its longtime midnight closure, and cruising was outlawed on First and Second Streets as they cut through the park.

Today, many of those problems have lessened, especially during the daylight, and while it's no longer the central park of Long Beach, it remains a pleasant spot for picnickers and families from the neighborhood who want to get away from their sixty-dollar parcels of land and enjoy some time in one of Long Beach's most enduring public open spaces.

THE GLORIES OF ALAMITOS

When the first edition of the *Long Beach Journal*, the new city's first daily newspaper, hit the streets on Jan. 27, 1888, the main front-page story was about a new area outside of town: "To the many new enterprises to which public attention is being called of late, none possesses more varied and attractive features than the Rancho Los Alamitos."

If that sounds like hyperbole, the intrepid reporter was just warming up:

Located upon the spacious Bay of that name, diversified by broad mesas, bold, undulating hills and sheltered valleys, with an ocean beach excelled in smoothness and breadth by none in the world, it presents a beautiful picture whether viewed from the sea or from its own commanding heights.

Its climate? "Salubrious." Its beach? "Magnificent! Perfectly safe for children." Its roads and paths? "Simply perfect, with not an obstruction to interrupt the course."

The article concluded with the prophecy that "the day is not far distant when it will not be in the remote east but here that the savant, the traveled, the student and the philosopher may seek and enjoy all that aesthetic taste may demand, or the highest civilization afford."

Convinced? Get out your pocketbook, then. An order of action in one of the first meetings of the Alamitos Land Company was to approve the sale of a 55- by 150-foot lot at Ocean Boulevard and Alamitos Avenue for $550.

During the mid-1850s, Thomas Stearns was the largest land- and cattle-owner in the southern part of the state. Included in his 200,000 acres of ranchland was the Rancho Los Alamitos. His land grabbing got a bit out of hand, however, and by 1862, according to a biographer, Stearns's "obligations were out of all proportion to his income."

The killing blow to Stearns's empire was the Great Drought of 1863–64, resulting in 1865 in the loss of Rancho Los Alamitos by foreclosure.

Just a few years earlier, John W. Bixby, a cousin of Jotham and Lewellyn Bixby (the pioneering fathers of Long Beach and owners of Rancho Los Cerritos to the north and west) arranged to buy Rancho Los Alamitos in partnership with Los Angeles banker I.W. Hellman and the firm of J. Bixby & Co. The group paid $125,000.00 for the rancho—a bit more than $0.60 an acre.

John W. Bixby planned and laid out the Alamitos Beach town site, and he did it with a flair for creativity and with an appreciation for its beautiful setting along the sparkling Pacific.

While the more practical William Willmore laid out the original Long Beach town site with the east–west streets running perpendicular to the avenues, the young Bixby designed his streets to bend along with the gentle arc of the coastline, with their avenues fanning off accordingly.

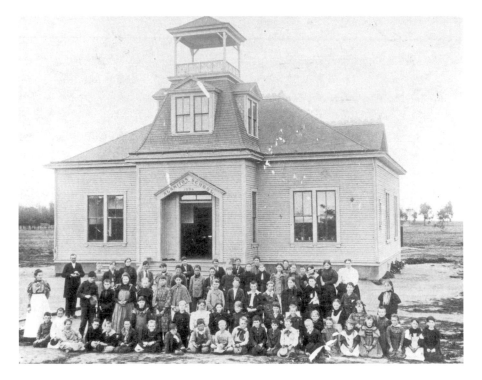

Alamitos School was opened in 1906 to serve the students of the Alamitos Beach town site. Located at Third Street and Hermosa Avenue, it became Burbank School in 1922.

And while Willmore envisioned an Ocean Boulevard skirting the bluff along the sea, Bixby left room for prestigious plots between the seaside boulevard, which he called Ocean Park Avenue, and the sea.

The town site, as laid out by Bixby, was twenty blocks long from east to west and just two blocks wide, with Second Street forming the northern boundary.

His finishing touch was to give the north–south avenues Spanish names, with the jarring exception of Kalamazoo Avenue, which would later become Kennebec, and he placed them in alphabetical order. That pattern was disrupted in later years as some of the streets' names were changed. Descanso became Orange, Independencia became Cherry and Naranja became Temple. Also, the Termino Avenue that was the terminus of the town site became Euclid, while the Termino name moved three blocks to the east.

The heart of Alamitos, smack in the middle of the track, was Alamitos Park, renamed Bixby Park in 1905 and nestled between Independencia and Junipero Avenues.

Bixby's role as a civic father of the expanding Long Beach was cut short when he died suddenly at age thirty-eight in 1887.

The remaining two partners and John W.'s heirs took up the work of completing the project. After incorporating as the Alamitos Land Company on January 27, 1888, they extended their town site north to Tenth Street. Above that, and out beyond Termino Avenue, the tract was divided into farm lots.

Should the readers of the four-page debut issue of the *Journal* have skipped the heavy news on page one, they couldn't have missed the large ad inside that crowed, in bullet points:

- *Alamitos joins Long Beach on the east.*
- *Alamitos is not Long Beach's rival, but her crowning jewel.*
- *Alamitos has the best site for a seaside town in the state.*
- *Alamitos is laid out on liberal principles.*
- *Alamitos has no saloons.*
- *Alamitos has a larger water supply than any town in Southern California.*
- *Alamitos has artesian water at a high pressure piped in front of ev'ry lot.*
- *Alamitos has the Southern Pacific Railroad at its door.*
- *Alamitos is an attraction for real estate now.*
- *Alamitos will be a word well known in 1888.*

THE LAND OF SUNSHINE

Here was this remarkable little town in the final months of the nineteenth century, a town that hadn't yet been plagued by slipshod development, never mind redevelopment. It was still, in fact, emerging from reincorporation and only just beginning to expand its boundaries.

In 1897, Long Beach's eastern border, originally Alamitos Avenue, pushed into Rancho Los Alamitos to Descanso (now Orange) Avenue, south of Fourth Street.

It had been incorporated as a city in 1888, disincorporated over controversies involving taxes and liquor in the summer of 1896 and reincorporated in the winter of the same year.

But throw away the politics and the business of running a squabbling municipality, and you had, in the last year of the century, a town that came close to paradise. That's why the seaside resort was featured in an article in the May 1899 edition of *The Land of Sunshine, The Magazine of California and the West*, edited by Charles F. Lummis.

The magazine, which would later become *Out West* magazine, devoted ten pages to Long Beach, a city of 2,500 "exclusive," noted the magazine, "of transients."

And, as beautiful as May can be in the Midwest, a reader back there could not be faulted for getting up and leaving the farm the minute he'd read the glowing praise that spilled from the pen of an anonymous writer for *Land of Sunshine*.

"Long Beach has been favored by nature in the highest degree," the article trumpeted.

> *The beach itself has no peer on the Pacific Coast—nor probably in all North America. Spacious in length and breadth; hard as a boulevard and perfect for driving, wheeling or walking; so free from rocks and so*

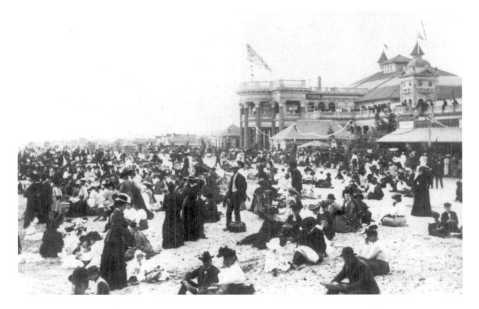

Long Beach was featured in a magazine called *The Land of Sunshine* in 1899. Sunbathers in the city appeared to be aware of the potential danger of too much sunshine.

gentle in its slope that bathing, even for the youngest child, is absolutely safe, and with the finest swells for the expert surf swimmer, it is the ideal beach in the United States.

The landscape is particularly beautiful; far behind the orchard-clad acclivities which fringe the town rises the snow-robed Sierra Madre, all the nobler for its 30 miles of distance. The pretty town along the bluff; the glistening crescent of the beach, passing through Devil's Gate, four miles east, to Alamitos Bay, three miles further on. The blue of the immeasurable Pacific in front, cut, 25 miles off the shore by the abrupt but always mysterious outlines of Santa Catalina; these make a picture not easily forgotten.

But enough about the view. How's the neighborhood?

To the home-seeker, Long Beach offers the best of schools, churches and business facilities, along with "good government." The high-school building is one of the handsomest in the state and has complete equipment for students in chemistry and other advanced courses.

"And the people?" we might ask, fishing for more gushing compliments. Why, the best, of course. "Its population is made up of intelligent and refined people," noted our discerning correspondent. "It has no rough element, and the high character of the population and the outdoorsness of its climate render it an ideal place for children."

Oh, please, don't stop now! Amusement? Diversion? Leisure activities? How do you like us in those areas?

"The unmatched natural advantages of the beach have been improved and not spoiled," replies the magazine.

Comfortable bathhouses, and an 1,800-foot fishing and boating wharf— famous for its catches of mackerel, barracuda, jew-fish, great bass and game yellowtail, and lighted its whole length with electric lights—a spacious pavilion adjoining the wharf and overhanging the surf, where one may dance, lunch or listen to music, are all at the visitor's command.

But alas, times change, as any of the relaxing seaside old-timers would tell you, and the needs of a rapidly growing town—and why wouldn't a

town matching that article's descriptions grow at any other pace?—can rarely be met without disturbance to the town. Long Beach would not remain cozy and quaint. Today, in fact, you'd be challenged to find a nook or hideaway that would remind you of Long Beach in 1899.

If there's a seaside resort anywhere today that's as perfect as Long Beach was in that year, the city bosses there should take a page from the *The Land of Sunshine* article and make it part of their mission statement: "The ideal beach resort is that which nature had made charming before man touched it all; a place attractive even without 'improvements'—and then an intelligent development of these advantages by people with taste, push and patience."

A VISITOR FROM IOWA

Long Beach's Iowa Picnic has for the past couple of decades drawn maybe a few dozen—no more than one hundred—Long Beached Hawkeyes to a shady spot at Recreation Park to pool their memories of their long-since-abandoned home state.

But the picnic, old-timers know, used to be one of the most popular events in Long Beach, annually bringing tens of thousands of people, with the crowds divvied up by county so as best to keep the memories from getting mixed up.

In the 1930s, particularly, Long Beach owed its growth to huge waves of Hawkeyes, most in their so-called golden years who were giving up the family farm for a forgiving climate in the sunshine of a beach town.

In an attempt to explain the attraction of Long Beach to the folks who remained in Iowa, the *Des Moines Register*, in 1937, sent a reporter, Harlan Miller, some two thousand miles to spend a day at the beach.

His report, headlined "Long Beach—The California Paradise for Aging Iowans," is our single favorite piece ever written about this town.

Here are some of the high points of Miller's day at the beach, as he reported to the folks back home:

> *At 7 a.m. the clang of the horseshoes begins. The retired farmers are at their chores, pitching ringers...Day has begun in the coastal paradise where so many thousands of Iowans go before they die.*

Behind the beach stretches the gaudy "pike," the amusement artery lined with open-fronted refreshment rooms and counters, its games of skill and chance, souvenir bazaars, liquor shops open even on Sunday; the arcade, a cavern of assorted sights and marvels. Here even a retired elder whose mortgages have gone a little sour can romp with discreet lavishness...

It is not an expensive paradise. Probably most of these elderly couples who have added the gilded adjective "retired" to their names have less than $100 a month to spend on the essentials and baubles of existence. Many live on $60 to $70 a month. Of this sum, about $30 would go for rent, $25 for food and clothing, $10 for doctors and medicines, $10 on riotous living—gasoline, tobacco, church collections, movies, postage, fantastic souvenirs for the grandchildren...

This cornfed riviera is geared to frugal spenders [but] a great many have ampler means. Hundreds have retired into rooms, suites and apartments at the Sovereign, the Omar Hubbard, Sharon Inn, Willmore, Cooper Arms and the ultra-swank Villa Riviera...

As Iowans began to flock to Long Beach in the 1930s, the *Des Moines Register* dispatched a reporter to the town to see what the entire hubbub was about. The writer described the Villa Riviera, quite accurately, as "ultra-swank."

At 2:30 comes the afternoon [Municipal Band] *concert on the beach, until 4, when several thousands will be listening, some through ear trumpets, to the well rounded programs, with the blue Pacific beyond to rest the eyes, and perhaps an unintended forty winks of nap in the sun…*

Toward evening it is time to return to the apartment for a simple dinner, or perhaps to dine out at one of the many inexpensive places where a retired appetite may be well satisfied for anywhere from 35 to 60 cents….

But it's a chronic complaint among the epicures that California offers no steaks like the steaks of the Mississippi valley, and the gourmets protest indignantly against what often passes here for fried chicken. At such moments they wonder whether California is really worthwhile…

[In the evening] *for an amazingly large fraction dancing becomes the consuming passion. Thousands go literally dance mad, and attribute their good looks and good figures at 70 to the giddy whirl of dances. There is little or no housekeeping, no office hours or chores, so they can dance all night and sleep all day if they like…*

Do the self-exiles go [to] *California and forget home ties?*

Well, hardly. A surprising number maintain a sort of ephemeral residence back home, pay their taxes there, and vote by absent voters' ballots…

They like to say, "This may not be paradise, but it's the grandest place in the world for us."

Yet it remains a debatable question whether the brilliant sunshine and the mild sheltered climate ever become a completely satisfactory substitute for the mellower glow of the old neighbors and the old neighborhood back home.

THE PACIFIC SOUTHWEST EXPO

Long Beach's first big bash, the giant party attracting the sort of worldwide attention that every emerging town hankers for, was the Pacific Southwest Exposition in the summer of 1928.

The expo was first intended to present exhibits demonstrating a decade's worth of remarkable progress made in the American Southwest and the cultural and commercial achievements of the nations that border

on the Pacific Ocean. But planning escalated to the point that, when the Pacific Southwest Exposition opened its gates on July 27 for a thirty-nine-day run, it had achieved grandeur on the level of a world's fair.

Sponsored by the Long Beach Chamber of Commerce and underwritten by the elite of the city, the exposition became the country's biggest tourist draw of the year, with 1.1 million people visiting the sixty-three-acre expo grounds.

The site, a desolate sand spit at the end of West Seventh Street, was cleared in February 1928, and gas, water, electricity and drainage were installed. The Park Board of Long Beach miraculously transformed sand dunes and choked brush into an artistic landscape of graveled walks winding through grounds planted with grass, flowers and transplanted palm trees.

The exposition featured Moorish architecture—white walls, domes, towers, minarets that were as authentic-looking as they were disposable. Buildings were constructed of plasterboard with an outer coating of stucco. Roofs were of canvas stretched taut.

California governor C.C. Young was the first patron admitted to the expo. In his address during the opening ceremonies, he told organizers and the citizens of Long Beach, "I congratulate you upon the miracle you have wrought in this beautiful city beside the Pacific…You are going to make this magnificent World's Fair one which will go down in history as the most beautiful and most inspiring ever undertaken."

More than twenty foreign nations participated, each represented by a building or exhibit.

In a rave review of the fair, a Los Angeles newspaper article exclaimed, "There is everything here to see and to admire, from baby food to immense aircraft guns from Fort MacArthur, from free travel movies to gas engines."

Some of the Pacific Southwest Exposition highlights included:

- A visit by presidential candidate Herbert Hoover. Hoover, on the campaign trail, was given a ride in the official coach of Napoleon Bonaparte, which was displayed in the French exhibit.
- Twice-daily concerts by the Long Beach Municipal Band in the bandstand by the Reflection Pool. The band members wore white, gold and orange uniforms specially ordered for the expo. Among the performances was "The Pacific Southwest

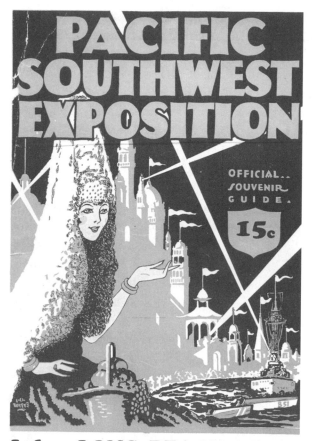

Sponsored by the Long Beach Chamber of Commerce and underwritten by the elite of the city, the 1928 Pacific Southwest Exposition was the country's biggest tourist draw of the year, with 1.1 million people visiting the sixty-three-acre expo grounds.

Exposition March," composed by the band's director Herbert L. Clarke.

- Three thousand local telephone calls handled each day over the seven trunk lines connecting the expo switchboard with the outside world.
- A $12,500 public address system that was used to broadcast announcements and entertainment over the festival grounds.
- Fiji Islanders, who "do more than hunt heads," according to a record of the event, demonstrated weaving and metalwork.
- A collection of four-hundred-year-old copper utensils brought by Bolivia.

- A Chinese exhibit valued at $500,000, which included a $50,000 rug.
- Visitors that included author Upton Sinclair, who had been living in Long Beach working on his novel *Oil!* Also in attendance were motion picture director Cecil B. DeMille, North Pole aviator Captain George H. Wilkins, movie actress Clara Bow and *Bringing Up Father* cartoonist George McManus.

In an afterword to *Story of an Epochal Event*, a history of the exposition published by the chamber of commerce, Wallace Teasdale Randolph Struble wrote, in the florid prose favored at the time:

> *The Exposition was in a peculiar sense* multum in parvo *of exhibition and entertainment; of surprises and fellowship. In the aggregate it was the result of fine thinking and planning, of management and execution; yet in its day-to-day operations it abounded in unexpected features, which, like Topsey, "just grew" out of its intriguing atmosphere. The memory of it will linger through the years.*

THE LONG BEACH HOTEL

If you think the Long Beach Hotel was an unimaginative name for the young town's first hostelry, you have to consider the fact that the term "Long Beach" hadn't been exploited much at the time.

When the hotel opened in September 1884, "Long Beach" had just recently been chosen as the name of the as-yet-unincorporated town.

One hundred years later, there would be two full pages in the local phone books of businesses and organizations using Long Beach in their name, but the Long Beach Hotel was one of the first to capitalize on the town's name.

The hotel was built on the south side of Ocean Avenue on the bluff at the foot of Cedar Avenue. It rose three stories above the street and five stories above the strand, with the two lower, beachfront floors serving as a bathhouse.

Also on the ocean side was a twenty- by eighty-foot veranda. The dining room faced the sea, and its southern wall was all glass.

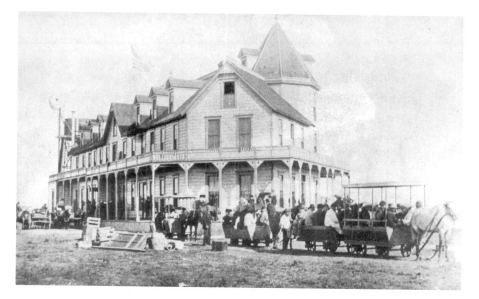

The "Get Out and Push" railroad was the modern and fashionable way to travel to and from the Long Beach Hotel. The hotel was built on the bluff at the foot of Cedar Avenue in 1884.

Beach facilities included a popcorn stand, swings and a picnic shelter. There were croquet and tennis courts on the grounds, and guests could stroll out on Long Beach's first pier, a relatively tiny structure at the foot of Magnolia Avenue. Only seven hundred feet long, it barely waded out into the breakers.

Each winter, as the vacancy rate rose during the off season, workmen added to the hotel. It peaked at 130 guest rooms.

A travel guide of the era described the $50,000 Long Beach Hotel as "containing all modern conveniences." These included speaking tubes on each floor, electric service bells in each room and a telephone connection with Los Angeles. Steam heat was added in 1887.

The year 1887, in fact, was a boom time for the city. Land speculation was driving the price of property to seemingly unrealistic heights. One block in Long Beach sold for $8,000 that year, and the Long Beach Hotel was packed with tourists who had discovered the town's natural wonders.

But in 1888, the bubble burst as financial depression brought the giddiness to an end. Soon, that $8,000 block would do well to fetch $500. The future looked fine for the hotel, though. A tour group from the East

had booked the entire hotel for late November, and plans were made to triple the number of guest rooms after their departure.

On November 8, though, there was only one family staying at the hotel, and the members of that family were the ones to give the early morning cry of "Fire!" which brought nearby residents running out of their houses.

Almost immediately, the city marshal and fifteen or twenty men were at the scene, but they hadn't so much as a bucket of water to toss at the flames. The gathering crowd watched as the blaze spread out of control and razed the building to the sand.

Long Beach's weekly newspaper, the *Journal*, which had been started by Amos Bixby and H.W. Bessac eleven months earlier, soberly reported on the disaster the following Friday: "By 2:30 the fine hotel was reduced to a bed of cinders and coals, and the people went home heavy hearted because of the great loss to Long Beach."

The Hottest Beach in Town

City bosses and breakwater apologists can brag all they want about the beauty of our local strand, but most beachgoers are goers to other beaches—especially Seal, Bolsa Chica, Huntington—because Long Beach, as a beach, just doesn't cut it.

But go down to Bay Shore Avenue or Fifty-fourth Place at Ocean Boulevard, turn your back on the Pacific and you're at one of the prettiest places in Southern California to spend a summer afternoon at the water's edge: Alamitos Bay—in particular the stretch along Bay Shore that goes from the Second Street bridge and follows the bay's southwestern shore until it hooks around toward Fifty-fifth Place, an area long termed "Horny Corners" in the local beachspeak.

The earliest town site pioneers, from back in the days when the bay was miles away from the eastern boundary of Long Beach—then Alamitos Avenue—hoped to not only build the city of Alamitos in the neighborhoods around the bay but also to turn the body of water into a world-class port to "break the monopoly of San Pedro and Wilmington" by bringing shipping business to the bay. Those dreams were, happily, dashed, however, when bay port backers couldn't convince the big railroads to come to that area.

Alamitos Bay, more than the ocean beach, has always been Long Beach's favorite water playground.

The port plan, moaned one of its promoters, "died aborning."

The idea of Alamitos Bay as a place to hang out for the summer was put forth in no uncertain terms by the Alamitos Land Company developers and the Alamitos Water Company in an advertisement in the *Long Beach Journal* in March 1888.

"All the world goes to Southern California," brayed the ad copy. "Alamitos, by the inevitable law of destiny, will be the social center of summer life."

In 1961, an old-timer, F.W. Cranston, recalled the bay's earliest days in a letter to *Press-Telegram* columnist Malcolm Epley.

"Alamitos Bay was called McGarvin's Bay after a man who caught sharks and rendered them down for the oil," wrote Cranston. "Belmont Shore was a tidal flat with salt grass and winding salt sloughs. These sloughs abounded in cockles, which we gathered in gunny sacks at low tide and went into the city [Long Beach] to peddle from door to door."

In those days of the late 1800s, Long Beach had a population of about five hundred, but as the decades flew by, the head count soared, and by the late 1920s, especially when the construction began of Marine Stadium as the rowing venue for the 1932 Olympics, the bay, fulfilling "the inevitable law of destiny," became one of Long Beach's hottest summertime gathering spots. And while the Long Beach strand has declined in popularity, the bay is as popular as ever—the current issue of *Los Angeles Magazine* has Alamitos Bay's Horny Corners listed as one of the best twenty-five Southern California beaches ("Powerboats, windsurfers, dinghies, and even canoes pass by, giving the inland waterway the vibe of the Florida Keys").

Changes over the decades have been mainly minor. Kids can still jump off the pier into the bay, but there are no longer diving platforms outfitted with perilous three-meter springboards. Rentable lightweight kayaks have replaced the old rentable heavy wooden dinghies. And from Memorial Day through Labor Day, barricades are set up, making it impossible to cruise in your car along Bay Shore Avenue scoping out the bodies that gave the Corners its lascivious adjective. You can, however, still cruise the stretch on your beach cruiser bike and take in the sizzling sights. Just keep your eyes, from time to time, on the road.

OLD NEW IS NEW NEWS 2

"If It's True It's in the Press; If It's in the Press It's True." That was the slogan of the daily (except Sunday) paper that was run, from 1905 to 1911, by C.L. Day and J.P. Baumgartner. In 1907, Long Beach was a town not overly weighted with important matters. This happy matter freed the staff of the *Press* to pursue their truths in other subjects. The citizenry as a whole was rife with stories, and many of them—and the paper's very slogan—assure the tales' veracity.

The top story on page one of the June 1, 1907 *Press* tells readers that

> *T.E. Patch, who resides at the corner of Fourth and St. Louis streets, thinks his neighborhood is getting a reputation for developing freak chickens. J.O. Harper, who resides across the street from Mr. Patch, recently came to the front with a freak story about a freak hen laying a freak egg of the double size every other day instead of a regular egg every day.*

Mr. Patch now claims to have a chicken which lays a double egg, but of altogether another class. It is an egg within an egg.

Mr. Patch is now considering the proposition of setting one of the freak eggs and is wondering whether or not it will hatch a chicken within a chicken.

Long Beach was a "dry" city in 1907, and the *Press* editors were heavily in favor of anti-liquor legislation. They didn't hesitate to print the names of offenders. Sometimes the public humiliation was enough to put the offender on the wagon for a bit, but one notorious repeat offender was Jose Romero, aka the Ninety-Day Kid, for his frequent ninety-day stays at the city jail for drinking. The *Press* reported one day that the Kid had been tossed in the pokey again: "He had just gotten out of jail yesterday morning and the strain was too great."

Days later, a good deal of hollering was heard beneath the office of the city clerk. "Whoop-ee! I'm the 90-Day Kid! Hurrah for the police! Let's have another drink," was, according to the *Press*, heard, and "the entire city hall gang was soon up in arms to abate the nuisance."

It was found that Romero and other prisoners had been assigned to do some cleanup work in the basement when they stumbled onto a hidden stash of hooch: "When the city marshal and his deputies entered the basement, they found Romero with a bottle of wine in one hand, a bottle of beer in the other and an empty whiskey bottle lying on its side, while two other prisoners were so drunk they could not move."

It was learned that the liquor had been stored there by a former city marshal. It had been misplaced and was supposed to have been poured out, said the *Press*. "None of the officers knew it was there." Truth.

The Royal Italian Band, one of the precursors to the Long Beach Municipal Band, appeared in the *Press* pages frequently. Generally, Long Beach citizens enjoyed listening to the band's public performances on the Pine Avenue Pier and at the nearby auditorium, but it appeared no one was happy to be their neighbor.

One day in 1907, the *Press* reported that

twenty-four members of the Long Beach Royal Italian Band and their friends and family have moved away from 214 Linden Ave, much to the relief of neighbors in that section. There has been much complaint to the

police and city officials of late to the continued practicing of the Italians in the building the past six months. The neighbors do not know to what point they moved, and say they do not care.

Some other odd and miscellaneous items culled from the no-doubt highly popular "Local News Notes" column in 1907 include:

- *J.E. Webb is mourning the loss of a handsome elk's tooth lost yesterday while about the pier. Mr. Webb regrets the loss of his charm, principally for reasons that it was taken from the grave of an Indian chief.*
- *Peter Wilson, a West Long Beach man, was the victim in an accident while rowing around the harbor yesterday. Some friends tickled him in the ribs, causing him to fall overboard. As he came up for the first time he was caught by the heels and pulled out.*
- *Where is Samuel A. Bradford, of Los Angeles, who came to Long Beach Thursday evening, and while here, suddenly dropped from sight? His wife has neither seen nor heard from him since that day. Bradford started for Long Beach Thursday evening saying he was going to the beach to enjoy a morning's fishing. His wife, who weighs 300 pounds, was here yesterday searching for him.*
- *The Elks' polo game yesterday afternoon attracted a good-sized crowd. The game is much harder on the players when played on foot, and not as exiting, but the Elks put up a good game.*
- *A meeting of the school board was held this morning, but no business of importance was transacted other than that of passing several bills.*
- *Two men arrayed in bathing suits and giving their names as W.C. Hogan and R.A. Blakeney were arrested on the strand yesterday afternoon by Policeman Will Franks and charged with insulting women bathers. It is charged that Hogan and Blakeney made themselves obnoxious to the ladies by swimming up close to them and asking them if they would not consent to be their wives. Several complaints were made to the police until it was found necessary to take the men to jail. They are said to have not been intoxicated.*

THE EMPIRE DAY DISASTER

March 24, Empire Day, fell on a spring Saturday in 1913, and Mrs. Anna Longfellow, of Pasadena; David Scott Black, of Glendale; and Mrs. Warren C. Lett, her son Harold and her daughter Dorothy stood among the crush of Brits, Canadians and Americans paying tribute to the late Queen Victoria and the Mother Country of Great Britain.

They stood with hundreds of other people before the locked doors of the old wooden Municipal Auditorium in Long Beach, minutes before the doors were to be opened and the program was to begin inside. Somewhere, a band was playing, and the impatient horde of revelers began to stomp their feet to the beat of the martial music.

That was one moment, and then they were all gone.

The upper deck of the two-level pier splintered and snapped, and hundreds of merrymakers disappeared. The crowd fell to the lower deck, slamming into a gathering of people that was waiting below, and then the entire mass of humanity broke through the lower deck and continued to plunge another thirty feet to the sand.

Mrs. Longfellow was dead, David Scott Black was dead and Harold and Dorothy Lett and their mother were dead. Fifty in all were killed; 174 were injured, and Long Beach became host to one of California's great disasters.

The scope of the tragedy has been narrowed somewhat over the decades; its impact has been lessened considerably as it passes from memory, and even its role in local tragedies has been superseded, especially by the March 10, 1933 earthquake thirty years later. But it was the biggest story in the country for several days as the list of the dead grew.

The report of *Long Beach Press* staff writer John Meteer that appeared in the evening edition on the day of the collapse maintains its feeling of terror and tragedy. An excerpt from his story follows:

> *Snapping the timbers of the lower deck as matches, the awful tragic homogeneity of splintering planking and shrieking humanity went down to the sand, just a few feet distant from the surf, at low ebb.*
>
> *For more than half an hour, as the rescuers labored, the victims of the catastrophe fought and tramped upon each other in their efforts to get their heads above the death trap where they could get a breath of air.*

Heart-rending scenes never equaled in the history of Long Beach were enacted on the beach as the dead and living were carried out and tenderly laid on the beach.

Many begged piteously to die. A lad of 10 years was seen to pass away in his mother's arms as she was raising a glass of brandy to his lips.

A broken-hearted father carried the limp and almost lifeless form of his 14-month-old baby up the steps to hunt for a doctor. His wife lay on the beach with her life crushed out. A mother saw her little boy smile and die at the Seaside Hospital, a half hour after he had stood and cheered with her as the parade disbanded for the Auditorium ceremonies.

History has furnished few scenes more piteous and tragic than are present today at the Long Beach hospitals. At the Seaside Hospital, where Long Beach physicians concentrated their efforts, every room was

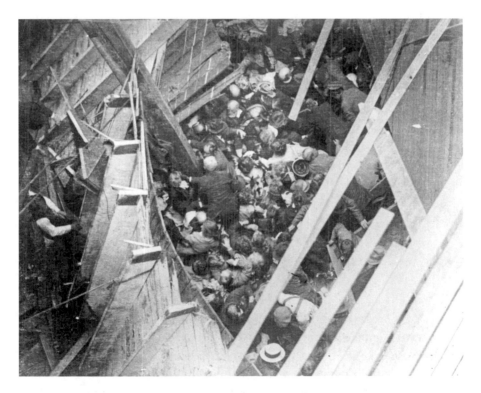

Fifty people died in the 1913 Empire Day disaster in Long Beach. The *Press* reported, "Snapping the timbers of the lower decks as matches, the awful tragic homogeneity of splintering planking and shrieking humanity went down to the sand."

filled. Cots were stretched in the hallways and the mangled bodies of victims were cared for on the porch and even on the very steps.

One very strong young man was weeping silently as he sat crushed and bleeding on a chair in the hall. "My wife and boys were with me," he said. "I don't know where they are now."

Another girl couldn't even remember what had happened. "I though Grandma was with me," she smiled from her improvised hospital couch on the floor. "But, really, I can't remember. Where are we and what is all this about?"

There was no hint of the impending disaster, and it was generally believed that the area of the collapse was safe. Crowds as large as the Empire Day throng had gathered there before.

But a subsequent investigation showed that the cause of the structure's collapse was the breaking of a four- by fourteen-inch girder. In a report ordered by a coroner's inquest, the inspection team, which concluded its investigation four days after the disaster, noted, "The girder had entirely decayed for some inches outside of its seat brace, which was imperfectly connected."

The investigators further noted, "It would have been a simple matter to have detected this decay."

Concurrent with the story about the investigators' report, the *Daily Telegram* ran an editorial in anticipation of impending lawsuits:

It seems appropriate that notice should be served upon certain designing persons that, while Long Beach proposes to meet every moral and legal obligation placed upon her by the late terrible disaster, she does not propose to be made the victim of unscrupulous men, who are now seeking to take advantage of the city's misfortune.

The editorial suggested that families and friends of the victims of the Empire Day disaster should "ignore the selfish importunities of lawyers and claims agents who are now, like vultures upon a battlefield, seeking a feast amidst their scenes of misery and affliction."

Nevertheless, 175 damage claims, totaling $3,507,005, were filed against the city. They were finally settled in 1918 for $400,000.

THE BAMBINO GETS BUSTED

In January 1927, Babe Ruth was in the on-deck circle of his greatest season, the one in which he'd swat sixty home runs. The Bambino was already the hero of millions of boys in America, to the delight of their fathers. When he died twenty-one years later, he would be eulogized by a New York writer and friend as "warm-hearted, fabulously generous, genuinely fond of children, greatly moved by the ills and trials of others, devoted to his family and friends—he would not have known how to deal with an enemy for the simple reason that he never had one."

And yet in Long Beach, on January 22 in the year of his greatest season, Babe Ruth was arrested.

Ruth had flown into town that afternoon to perform in three shows at the State Theater on the ground floor of the Jergins Trust Building on Ocean.

The show was basically just an appearance on the stage. Ruth would invite kids up, give them a few batting tips, hand them each an autographed baseball and then send them on their way, their lives forever altered by the experience.

Hours before he was scheduled to appear at the State in the first of the three shows, Ruth was in his dressing room when the theater manager Roy Reid came to warn him that Long Beach judge Charles F. Cook, of the municipal court, had certified a warrant for the ballplayer's arrest that had been sent up from San Diego, where Ruth had performed a week earlier.

Officials in San Diego charged Ruth with permitting the appearance of children on the public stage without permits first having been acquired from the State Labor Commissioner—a violation of the child labor law.

The deputy labor commissioner of San Diego made out the warrant for Ruth's arrest, and deputy commissioner Harvey Fremming made the arrest in Long Beach.

When informed of the impending arrest, Ruth was steamed and remarked to reporters who had hurried to the theater to accompany him to police headquarters, "They forget how much I've done for kids. I've done nothing that would harm them. I've only tried to give them a little sunshine."

By the time he arrived at the police station, Ruth was in much better spirits, and after going through the formalities of the arrest, he grinned

The law caught up with Babe Ruth in 1927 when the Yankee great was apprehended in Long Beach for violating the child labor law in San Diego. He grinned as he paid his fine in cash to Long Beach Police Department sergeant Joe Hale.

as he paid his fine, peeling twenty-five crisp twenty-dollars bills out of his pocket and handing them to the desk sergeant, Joe Hale.

The entire process was finished in time for Ruth to proceed to his sold-out engagement at the State Theater. The deputy commissioner looked on and said that he saw nothing that violated the child labor law.

"Ruth's arrest illustrates how a man's love for children sometimes acts as a boomerang," a writer declared in the following day's newspaper.

> *His chief motive in getting the boys on the stage and presenting them with autographed baseballs was to give pleasure to the boys themselves.*
>
> *In hundreds of American cities and in every village and inhabited part of the United States where there are boys there will be found a worshipper at the shrine of Babe Ruth. The redoubtable king of swat has perhaps given more pleasure to more boys than any one living man.*

No man to hold a grudge, Babe Ruth returned to Long Beach later that year, at the conclusion of the 1927 World Series in which Ruth's New York Yankees pounded Pittsburgh in four games. He was in town with teammate Lou Gehrig to play in an exhibition game at Shell Park (near today's intersection of Stearns Street and Redondo Avenue).

To the disappointment of some five thousand ticketholders, the game was rained out and canceled, and Babe and Lou spent the day enjoying the view of the city from the Breakers Hotel.

Babe finally got a game in when he came to Long Beach in 1931 as part of an exhibition tour at the end of the season.

People in the bleachers on that October afternoon would, for the rest of their lives, know the answer to what would become a tough sports trivia question: who played one game at first base for the Houghton Park team and swatted two home runs in a 19–3 rout of the Shell Oilers?

The Resting Place

The old Long Beach Cemetery is typical of the best graveyards. It's small, a little more than three and a half acres. It rolls and tumbles over gentle knolls and under majestic shade trees that muffle the noises and sweeten the air from the living city outside its gates.

Most of the tombstones here are old. Some go back to the days of Willmore City in the 1880s. There are few newcomers to this place. Mostly full now, a new headstone appears every few months, but for the most part, the names here are the names of a long-ago Long Beach. Several Heartwells are buried here, as is the patriarch of the Wardlow family, his wife and several relatives.

William E. Willmore, the town's founder, is buried midway up the cemetery along Orange Avenue. Farther to the north is a large Bixby mausoleum, though none of that family is interred there.

Most of those buried in the Long Beach Cemetery have been forgotten over the years. Few graves are decorated with flowers. Visitors come not so much to commemorate but to satisfy a curiosity.

During the early to mid-1930s, when Long Beach's less notable pioneers were reaching advanced age, *Long Beach Sun* columnist and early historian Walter Case conducted interviews with many of them, and

many of these common folk found their final resting place in the tiny Long Beach Cemetery.

Mattie Bell Mundell was twenty years old when she and her father and mother first came to Long Beach in 1886, ending a three-month journey from their home in Cincinnati.

Two years later, the *Journal*, Long Beach's first newspaper, began publication, and Miss Mundell was taken on as an "outside correspondent." "Outside" because she lived in what then was far from town, out near Hill Street and California Avenue in an area then known as "The Willows."

Her cousin Byron Lyster had come to The Willows in 1870 and bought ten acres there for $100. In his older years, as Long Beach crept toward its outposts, Lyster would recall that the only homes between Westminster and Wilmington were the haciendas at the ranchos Los Alamitos and Los Cerritos.

And his cousin, Miss Mundell, remembered how the family stopped in Wilmington to ask for directions to the area north of Long Beach, and how, when they reached their destination, "the valley seemed very wild, with its ducks, geese, quail and rabbits—and the weird cry of the coyote at night."

Mattie Mundell was buried at the Long Beach Cemetery on January 24, 1941. Eliza, Mattie's mother, was buried there in the summer of 1916. Byron Lyster was laid to rest there on October 19, 1932.

In 1887, the year before Long Beach was incorporated, Zoe and Linnie Osborne were young girls traveling with fellow Quakers on a chartered Santa Fe Railroad train to the Pacific coast from their home in Lawrence, Kansas. After a two-year stay in Long Beach, during which time the sisters attended the Pine Avenue School, they returned to Kansas.

Carl Hendrickson came to Long Beach with his mother in 1884. The two lived at the Long Beach Hotel for a while before moving to a house on American Avenue.

Hendrickson attended the Pine Avenue School with the Osborne sisters, and after the girls left Long Beach, young Carl especially missed Zoe. In 1895, he went to Kansas to marry her, and the couple returned to the booming resort town of Long Beach.

Besides making several deals in real estate, Hendrickson owned one of the first Ford dealerships in the city.

In 1933, the widowed Linnie Osborne Wixson came back to Long Beach so she could live near her sister. She moved into a house next to the Hendricksons at 334 Linden Avenue.

Carl was buried at the Long Beach Cemetery in 1945; Linnie, in 1956; and Zoe, in 1960.

Dr. W.L. Cuthbert was a strong believer in music and in the benefits of good climate. It was for the latter reason that he brought his daughters Nina and Georgiana to Long Beach in 1887.

Georgiana was frequently weak with illness and used a wheelchair until the curing climate of the town renewed her energy.

Dr. Cuthbert became a health officer in Long Beach, but he was better remembered as the leader of the Cuthbert Family Band, which played at religious gatherings and other events in the town's early days.

He died at the age of ninety-one and was buried at the Long Beach Cemetery on March 13, 1922. Georgiana was buried next to her father in 1946. Nina was buried in 1960 next to her husband, Edward Hendry, who died the year before.

John F. Corbett had his blacksmith shop on the corner of the alley between Pine and Pacific Avenues. He told Case about those days before the twentieth century.

There was the ocean on the south and Signal Hill on the north and very little in between. The country east of town was one huge barley

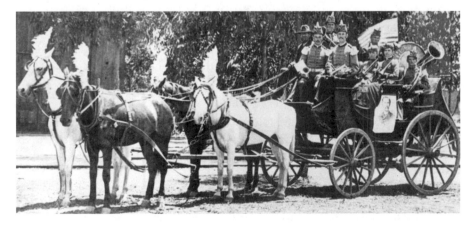

The forerunner to the Long Beach Municipal Band, the Cuthbert Family Cornet Band, shown here near Third Street and Locust Avenue, was founded in 1888.

field and cows were picketed on Pine Avenue to keep down the grass. Across the street from the blacksmith shop was a livery stable where all the boys of those days hired their rigs to take their girls for a drive along the beach.

Among Corbett's jobs was some ironwork on the Pine Avenue Pier and the city hall building.

In 1902, when the infant city organized its first fire department, Mr. Corbett was elected as chief. He resigned the following year to go into real estate.

On September 9, 1940, he was buried at the Long Beach Cemetery.

Dora Czerny came to the United States from Europe in the 1860s and married in 1865 in New York City. She gave birth to ten children, but eight died in infancy. It's unclear now what became of the surviving children and whether her husband died or left her, but in any event she came alone to the Pacific coast, to San Francisco, in 1882, and in 1887, she moved to Long Beach and became a housekeeper at the Long Beach Hotel.

Three months later, Mrs. Czerny rented a small bathhouse that belonged to the hotel, and she ran it for fourteen years. She later managed the "surf bathhouse" under the original Pine Avenue Pier, and still later, she built the East Side Bathhouse, described as a "more pretentious place than her original place of business." By the side of the bathhouse, she built a cottage of six rooms where she lived.

She died in the spring of 1927 and was buried on June 6 at the Long Beach Cemetery.

William Evens opened a little grocery store on the southeast corner of Anaheim Street and California Avenue in 1902. He told Case in 1934:

I eventually sold out and when someone suggested that Sugar Town [Los Alamitos, home of a huge sugar beet plantation] *would be a good location, I walked there to investigate. The owner of a frame building containing a big room offered it to me for $10 a month rent, evidently thinking I would be living in it. When I began to mention partitions and shelving, he realized I wanted it for a store, so he said the rent would be $50. So I walked back to Long Beach.*

The Columns

In December 1903, Evens opened a one- to twenty-three-cent store downtown on the west side of Pacific Avenue, just south of Fourth Street, and later moved to 442 Pine Avenue. In 1906, he joined the Elks Club, and when the lodge moved to a second-floor room in a building across the street from his shop, Evens spent a lot of time playing cards there. He would leave the store unattended while he played.

"I would sit near the window," he explained,

> *and keep my eye on the front of the store as well as on the cards. If I saw someone going into the store but knew the person well enough to believe he or she wouldn't spend more than just a few pennies, I'd just keep playing cards and let the prospective customer wander out after awhile wondering why there was no one there to attend to business.*

He continued to run his shop at various locations until he retired in 1932.

Ten years later, on August 8, he was buried at the Long Beach Cemetery.

Bertha Truax Bellow's father, R.C. Truax, was a conductor on the Southern Pacific train that came into Long Beach. It was in the 1920s, and she rode the train when it first steamed into town.

"I was in the baggage coach with my father," she wrote in a letter to Case in 1935.

> *There were Southern Pacific officials aboard who made speeches. There were many flags and other decorations and the Cuthbert Family Band was playing as the train, consisting of the engine and two cars, stopped on Second Street [now Broadway] in front of the center of the park.*
>
> *I ran down a broad boardwalk that extended through the park to see the ocean for the first time in my life.*
>
> *Later, we lived in a house just across from the north end of that walk, and I was very happy as a child because of this walk that seemed to lead from our front door straight to the ocean.*

Bellow's letter ended: "Long Beach has been and always will be the dearest spot on Earth to me."

And so she remains there. She was buried two days after Christmas in 1944 at the Long Beach Cemetery.

THE CRAZY EIGHTS OF 1932

Long Beach's involvement in sports, both in its contribution of athletes to the world of athletics and as a host city for everything from Olympic archery to Formula One auto races, is so huge that it can't even be dealt with in anything shy of a set of encyclopedias except on a superficial level.

Can we pick out the single most exciting moment in the history of sports in Long Beach?

Can and will.

You wouldn't think it would be rowing, but that's what we're going with: the Tenth Olympiad in Los Angeles featured rowing at Long Beach's Marine Stadium, a venue built specially for the games.

The excitement in town was intense as the rowers and fans came from all over the world to watch the greatest oarsmen in the world glide over the stadium waters. Some sixty thousand spectators watched on Friday, August 12, as Germany edged out Italy by 0.2 seconds in the four-oared shells with coxswain final and the United States handily walloped Poland in the pairs with coxswain final.

Saturday, August 13, brought a similarly large crowd to the course—although it would've been larger had it not been on the same day as the Iowa Picnic, held at nearby Recreation Park—to see, especially, the main event: the rowing eights.

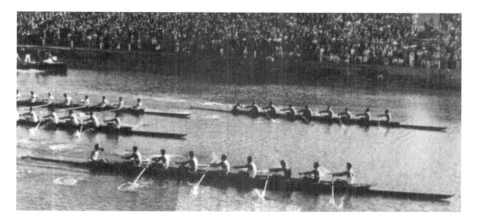

"Forty! Forty-two! Forty-four! Faster and faster the blue oars of California cleaved the water, now up to an unprecedented 44 per minute. Fifty thousand pairs of eyes looked on in amazement. They were watching one of the greatest moments in international sports history."

The United States had a three-Olympics winning streak in the eights, going back to 1920, but Italy had torn up the course in an earlier heat, and Great Britain, which had dominated the class in the games before the United States started its streak, was a serious contender.

Representing the United States in the eights was the University of California crew, with names sounding even more British than Great Britain's: Edwin Salisbury, James Blair, Duncan Gregg, David Dunlap, Burton Jastram, Charles Chandler, Harold Tower, Winslow Hall and Norris Graham.

The race started at 4:20 p.m. on Saturday, and from the first stroke, the crowd had the sinking feeling that the Cal boys were doomed to lose the gold.

We weren't there, but one of the *Press-Telegram*'s finest sportswriters, Art Cohn, was. His report appeared in the next day's paper. "For the first time in 20 years of Olympic rowing America was on the brink of defeat in the eight-oar classic," wrote Cohn.

"The blue-jerseyed Fascists had set a withering pace to lead three-quarters of the way. Time after time they had fought off the fiery California challenge. Only five strokes more and America's eight-oar supremacy would have been checked for the first time since 1912."

Thirty-six strokes a minute was Cal's pace, while Italy's was close to forty. With the end in sight, Cal's coxswain, Graham, asked for the impossible, taking his crew to an insane pace. Wrote Cohn:

> *Forty! Forty-two! Forty-three! Forty-four! Faster and faster the blue oars of California cleaved the water, now up to an unprecedented 44 per minute. Fifty thousand pairs of eyes looked on in amazement. They were watching one of the greatest moments in international sports history.*

The race was less than seven minutes in duration, but it seemed like the oarsmen from the two countries had been going at it for hours.

"Inch by inch the Bears crept up on the Italians," Cohn wrote. "Twenty yards from the finish they were locked bow and bow. Somewhere Italy had found the answer to the Bears' challenge. Again they jammed their needle-nosed prow ahead by inches."

Then, the final push, or in Cohn's words, the U.S. craft "leaped as if alive while a throng gone mad shrieked itself into a state of exhaustion."

These were days long before electronic timing and instant replay. A few painful seconds ticked by before the announcement was made: the U.S. team crossed the finish line one-fifth of a second—less than twenty-four inches—ahead of Italy.

Over at the park, about fifty thousand Hawkeyes must have been startled briefly by the redoubled roar of a like number of sports fans. The chitchat, one imagines, was quieted just for a moment as looks were exchanged, and then back to the normalcy of picnicking, talking about crops and weather. Whatever the ruckus was, they could read about it in the paper tomorrow.

WHEN THE KLAN HAD CLOUT

The Ku Klux Klan isn't big on being outnumbered, so Long Beach, the most ethnically diverse city in the United States, isn't exactly fertile ground for a would-be grand dragon or exalted Cyclops to plan a coffee klatch, never mind a klavern.

Back in the 1920s, though, the Klan gave it a go here, with massive demonstrations in San Pedro and Long Beach.

It wasn't all about race and religion. Though the KKK loudly expressed disdain for blacks, Jews and Catholics, it also attacked socialism and communism and in an early local rally, some twenty thousand members of the Klan reportedly "poured into San Pedro over every highway" on March 1, 1924, to protest "radical elements"—chiefly the Industrial Workers of the World (IWW), which had its offices at Twelfth and Center Streets in San Pedro, from which it urged solidarity among all workers and unions.

The Klan members met in a local field and assembled around a fiery twenty-foot cross after parading through town.

Police reported no disturbances from the demonstration, though the fear must have been palpable, as the story in the *Long Beach Press* the next day detailed how IWW workers had been singing "Solidarity," but "the song dropped to a whisper as the Klan pressed closer to the building."

The KKK also staged a similarly huge turnout in Long Beach on the night of October 2, 1926, as an estimated twenty-five thousand Klansmen from all over the state met in Bixby Park to listen to national

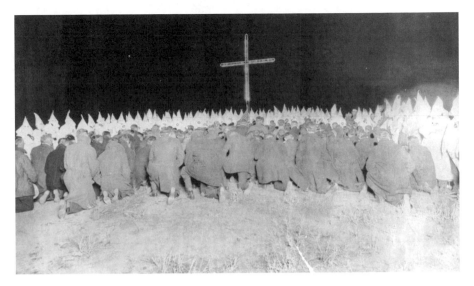

A *Press-Telegram* writer, recalling the day the Ku Klux Klan came in huge numbers to Bixby Park in 1926, wrote, "No one recounts today how he made the long march…There are some things most people would rather forget."

Klan leader J. Rush Bronson, who acknowledged that the Klan was anti-Semitic, anti-black, anti-Catholic and antiforeigner but denied that the Klan ever participated in acts of terrorism.

The throng marched along Ocean Boulevard to Long Beach Boulevard, north to Broadway, west to Cedar and back down Ocean to the park. The paper reported that there were many flags and lighted crosses, and a plane flew over with a lighted "KKK" on its wings.

Over the years, there have been rumblings about the Klan in local cities. Self-proclaimed leaders with no substantial followings have popped up from time to time to rattle on about something or other, and the occasional Klan "kopier" has emerged to plant a flaming cross on a frightened family's front lawn. But the brief explosion of activities of the '20s disappeared quickly and quietly and left little in the way of a historical trail.

"It's a funny thing about the Klan," a *Press-Telegram* writer mused forty years ago. "You almost never meet an ex-Klansman. No one recounts today how he made the long march on Oct. 2, 1926. No one admits to feeling the almost hysterical enthusiasm the Klan engendered in its day. There are some things most people would rather forget."

LADIES OF THE CLUB

Back when Ike ran things, it seemed to us like the world was overrun by nice-dressed ladies who subsisted on finger sandwiches and took an inordinate interest in drinking tea while conversing about matters of worldly interest.

We spent a lot of time crawling around the feet of our grandmothers and great-grandmothers during the mid-1950s, and while we're not certain if they were members of Long Beach's Ebell Club, they could've and should've been.

Adelaide Tichenor, who called seventeen ladies to her home for the purpose of organizing a literary or travel society, organized Ebell in 1897.

According to ancient Long Beach historian Walter Case, a "tourist section" was formed to explore, without leaving Long Beach, "Travels Through Italy."

The original Ebell group turned out a collection of eighty papers written on the subject of travel through Italy, and it was presented as the program for the club's first year.

Adelaide Tichenor's many accomplishments include the founding of the Ebell Club in Long Beach in 1897.

The Ebell Club wasn't founded solely for the continuing education of its members, though. From the outset, it was determined to fill a philanthropic role in the community. Its first benefit featured a lecture by the Reverend Haskett Smith, which raised $12.50 for the local library. The following year, accounts differ on whether $31.00 or $41.00 was raised for the purpose of sprinkling down the dry, dusty streets of Long Beach.

By 1898, the Ebell's roster had grown to forty-three, with more joining up each year. Their interests and causes were eclectic.

In 1899, "it was moved, seconded and carried that the members of the society remove their hats at all church services."

On December 2, 1901, Tichenor moved that a committee of three be appointed to confer with city officials in regard to the town securing a dumping ground.

On February 3, 1902, according to the minutes, "many members and guests joined in a heated discussion on the various phases of temperance work. After delightful refreshments, the meeting adjourned."

The first Ebell clubhouse was opened the day after Christmas 1905 on West Ocean Boulevard at Daisy Avenue. Tichenor helped design the building, and a nautical theme, including seashell light sconces, carried throughout the rooms.

A still-increasing enrollment, coupled with the deterioration of the Daisy clubhouse, led to a need for bigger digs, and the glorious $250,000 clubhouse, which is still in use today, was built on Cerritos Avenue at Third Street, on the outskirts of town, in 1924.

Less than a decade later, much of the building was damaged in the March 10, 1933 quake. A loan of $101,200 was secured for the rebuilding, and to help in the cause, satirist Will Rogers loped into Long Beach to give a talk before a sold-out crowd at the Municipal Auditorium, bringing $1,148 toward the rebuilding effort.

World War II saw the Ebell Club and clubhouse in full operation. The place was abuzz with ladies knitting and sewing, rolling bandages and selling bonds.

And so it went for Ebell, with its membership always growing through the '50s and into the '60s, with a roster that approached three thousand before things changed.

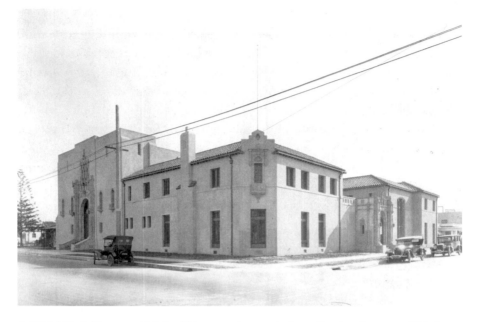

A $250,000 clubhouse, which is still in use today, was built on Cerritos Avenue at Third Street, then on the outskirts of town, in 1924.

But the club began losing membership both through attrition and dwindling interest from the younger generations. The group sold its prestigious clubhouse to a private group that rents the facility for weddings and other special events.

The club, which numbers fewer than one hundred members now, recently met in January 2012 to celebrate its 115th anniversary.

THE GREAT RACKETEER

Growing up in our life of music, I've heard a lot of songs butchered, often in a good way: the Sex Pistols' rendering of "My Way" comes to mind rather rapidly, with the Replacements' "Hello, Dolly" hot on its heels.

But no one in the history of music brought more destruction and deconstruction to music—despite the grumblings of a generation even older than our own regarding the racket that issued at great decibelage from our stereo record players—than Lindley Armstrong "Spike" Jones.

Spike Jones, who made a name for himself as a master of banging on pots and pans, bleating through various plumbing miracles of brass and tin, shooting guns, tooting bike horns and just all around making a joyful cacophony, spent his formative musical years in Long Beach, chiefly in music classes at Poly High back in the late 1920s.

Jones was born in Long Beach, but his family took off for the Imperial Valley when he was a year old. When he reached high school age, however, he had already become an accomplished drummer and wanted to return to Long Beach to further sharpen his chops at Poly, which had (as it has now) a national reputation for excellence in its music program.

Jones's mom let him move to Long Beach, where he got a room on Sixteenth Street in which he would set up his kit and bash away in accompaniment to a radio cranked up to ten.

As a drummer, and eventually drum major for Poly's band, his talent grew by bounds, and as the late Long Beach historian Bill Harris recalls in the book, Jones spent every moment of his young life learning more and more about the art of percussion.

At Long Beach Municipal Band concerts, Jones would wait until intermission, when he would go to the bandstand and take timpani lessons from the Muni Band's renowned timpanist O.F. Rominger for fifty cents.

Spike played live every chance he got. He performed Sundays with the First Methodist Junior Orchestra, and on weekdays he played around town with Rankin's Cadillac 8, sponsored by local Caddie dealer John Rankin.

Later, he fired up a band called the California Tantalizers, which played every morning before school on L.B. radio station KFOX, as well as performing lunchtime shows in Poly's cafeteria.

In 1927, Jones fired up his most popular Long Beach band, Spike Jones & His 5 Tacks, a six-piece Dixieland group that also featured Bill Harris on trombone. That band played all over town and had regular shows on KFOX and KGER.

After his graduation in 1929, Spike moved up to Los Angeles and would become a national favorite, finding a niche as a madcap humor performer, spoofing Hitler with his classic "Der Fuehrer's Face" and horsing around with such brilliant novelty fare as "Never Hit Your Grandma With a Shovel."

Jones returned to Long Beach several times after hitting it big nationally, and in 1953, he came back to Poly to receive an award from one of his former music teachers, Tony Gill. The award read, "To the graduate who has done the least for the advancement of music in America."

It was meant in a good way.

THE WHALE'S TALE

Reader Judy Berg writes:

> *I grew up swimming at the Colorado Lagoon in Long Beach during the late 1940s and throughout the '50s. At the east end of the lagoon was a cage that housed what I thought to be a dinosaur. I was recently told that it was a whale. Could you please identify this mammal and tell me where it now resides?*

It was dead on arrival, the whale was, when a pair of beachcombing teenagers, Arthur Read Hewitt and Lewis Lang, on May 20, 1897, lassoed it. The kids swam out about 150 yards, tied a rope around the tail of the sixty-three-foot female finback whale and, with the help of the then-whomping surf that thundered onto the strand in those days, as well as some manual labor from a group of house movers and their mules, dragged the body onto the sand at the foot of Alamitos Avenue.

Then the fun began. Bob Lynn, editor of the local paper, the *Long Beach Eye*, dubbed the whale Minnie and trumpeted the opinion that the dead behemoth could make some money for the city.

The teenagers were dispatched in a hurry. A group of entrepreneurs offered them $160 or several acres of Signal Hill property in exchange for the carcass. A no-brainer: $160 it was. Off they ran to squander their wealth, while various folks began working on Minnie.

People came in great numbers to gawk at the monster of the deep, while the *Long Beach Eye* saw gold, or at least fame, in the whale's bones. An editorial proclaimed that Minnie "would be a drawing card for Long Beach. The little city of Chicago has in its park a whale 25 feet in length, a mere toy compared to our fish. Excursionists from all over the country would view our whale with awe."

After Minnie the whale was captured in Long Beach in 1897, her bones were moved from one place to another, including their last public display at the Colorado Lagoon.

Crowds enjoyed a gruesome sight when, after Minnie had overstayed her welcome and had begun to, as we say, "ripen," William Haskins, a barber/taxidermist, was called in to chop the carcass down to the bone. The blubber was buried on the beach, and Minnie's bones were boiled, bleached and then reassembled and displayed in downtown's main gathering place, Pacific Park (which would, once it got a Lincoln statue, become Lincoln Park).

The town fell in love with Minnie immediately. The *Eye* gushed, "Long Beach is now in possession of a wonder of the world."

The citizenry guarded the bones like a dog. In 1908, industrialist/ philanthropist Andrew Carnegie offered to build a beautiful public library at the park, right where Minnie's skeleton was on display.

Let's see…a free library or keep the whalebones where they are.

City leaders hemmed and hawed over the issue for a full year, until one of the greatest compromises in history resulted in the library being built with the whale's bones on display in the basement.

That held until the 1920s, with a brief civic flare-up occurring in 1919, when the Long Beach Chamber of Commerce wanted to put Minnie on a national tour to use it as bait to lure more visitors to the seaside resort town. The city council nixed the plan out of concern for the whale skeleton's safety.

Minnie finally made it out of the basement in the 1920s, when her bones got to bask in the sun parlor at the end of the Pine Avenue Pier.

In 1934, after the pier was damaged in a storm—and we're finally getting to the answer to Ms. Berg's question—Minnie was moved to a pavilion next to the Colorado Lagoon.

She did fine there for a couple of decades, back when the Colorado Lagoon drew big crowds on sunny days to enjoy the cool and clean water (talk about ancient history!), but by 1956, people had a different idea of what was a big deal. TV had been invented. Disneyland had opened.

Minnie was moved yet again and stashed in a city garage out by the airport.

In June 1960, some teenage boys once again discovered Minnie. These boys were digging in a barley field when they discovered some vertebrae that they understandably figured belonged to a dinosaur. Further literal and figurative digging revealed the bones to be Minnie's, and it was figured that someone in the city had buried the bones to make room for other things in the garage.

After a brief and unsuccessful play to have the bones re-reassembled and displayed next to the then new Long Beach attraction, the *Queen Mary*, the bones of Minnie were donated to the Los Angeles County Museum of Natural History, which now stores the unassembled skeleton, minus several smaller bones, in its marine research center in Vernon.

THE WORLD'S GREATEST RIDE

One of the most eye-catching constructions at the Pike at Rainbow Harbor, Long Beach's new entertainment, restaurant and housing complex, is a pedestrian bridge inspired by the old Pike's most cherished attraction: the Cyclone Racer.

As bridges go, it looks OK, but it no more replaces the World's Greatest Ride than a shiny Lincoln penny replaces the sixteenth president of the United States.

Maybe "cherished" is too lovely a word for the memories of those who rode—or refused to ride—the mighty coaster. We rode it once during its dying days and wouldn't ride it or anything like it again unless a significantly life-changing amount of cash awaited us in a satchel at the other end.

Terrifying or thrilling, the ride remains huge in the memories of Long Beach locals and visitors and is likely to remain so. An issue of *RollerCoaster*

magazine devoted its cover (a detail from a 3-D model of the Cyclone built by Larry Osterhoudt, of Downey) and a dozen pages on the history of the Cyclone Racer packed with everything you could ever hope or care to know about the attraction, right down to the serial number of the last ticket taken at the loading platform.

When we recently asked readers to share their memories of the old Pike as the new Pike prepares to open, the most frequently cited attraction in letters and e-mails was the Cyclone Racer, which opened on Memorial Day 1930 and ran on through September 15, 1968.

Sharon Thurtle, of Norwalk, forwarded a photo of her cousins after a ride on the racer in the 1950s. Cousin Cookie looked particularly eager to disembark.

"My best friend and I would ride the Cyclone Racer often," writes Thurtle. "We always picked either the front or the back car so we would get the full impact. I now have the bad neck to prove it!"

As a senior at St. Anthony Girls' School in 1966–67, Barbara Beland O'Connor and her pals found the Pike to be "one of our favorite 'get-aways'"—another name for truancy!

"We would pile as many of us who could fit in one car and drive like mad down to the Pike, which was only a few blocks away," recalls O'Connor.

"The Cyclone opened each weekday at noon, and if we timed it just right, we could take several rides before we would have to cram ourselves back in the car and make it back to campus before anyone was the wiser."

Some people with otherwise fond memories of the Pike were justly frightened of the Cyclone Racer.

"In 1945 my mother and father took my brother and me on the Cyclone Racer," writes Barbara Jennings, of Seal Beach. "They loved it [but] they darned near had to carry me off, I was so scared. I'll never go on anything like that again, and I'm 71 now."

Robert Wilson, of Long Beach, lived and worked in and around the Pike during the 1940s, and he shared several memories about classic Pike attractions, but, he writes, "the occasional accidents, including deaths, kept me from riding the roller coaster. However, I enjoyed standing on the pedestrian walkway, just a few feet from the tracks, feeling the structure shake and listening to the shrieks of the passengers."

Scott F. Gray was among the last to ride the coaster. His parents took him to ride the legend on its last night of operation.

"After I got off the ride, my dad noted that it looked to him like the supports were kind of rocking in and out of the asphalt, and that it was probably time to tear it down.

"The Cyclone Racer was the best thing the Pike had going for it," writes Gray. "That is, aside from the sheer seamy nature of the place, the diving bell, Skee-Ball, the tattoo parlors (and watching people get them), the food—oh, just about everything, huh?"

OLD NEWS IS NEW NEWS 3

The following items appeared in the *Long Beach Breaker* weekly (Saturday) newspaper in the first half of 1897:

- *The stories published to the effect that Ellen Beach Yaw had died recently from the bursting of a blood vessel or vein in her throat consequent upon the straining of her voice is a canard. While she suffered somewhat a few weeks ago from sore throat, her condition is now nearly normal.*
- *Rev. Mr. Fisk informs us that he saw on Tuesday, just at the outer breaker line, in calm water, what at first appeared to be a floating log, but soon it made a sudden descent and then came up again. It had a head resembling that of a turtle, and there were four very large fins on its back, which the creature waved in various directions. As nearly as he could judge, the creature was about 20 feet long.*
- *A game of baseball will be played at Gallatin, near Downey, today between the club of that place and the Amateurs of Long Beach. The wagon will start at 8 o'clock from the corner of Third and Locust, the round trip being only two bits.*
- *Mr. John Dillon, of Long Beach, has a wrought iron nail which Alex Turner, of Franklin, Indiana, took from the house formerly occupied by George Washington at Mount Vernon, Virginia, while on visit there in 1885. He gave it to Mr. Dillon, who keeps it in a small leather case.*
- *Who lost the belt that hangs in the window of this office?*
- *Months ago this paper had occasion to "call to book" an individual who visited much abuse upon his wife. Indications are that the dose*

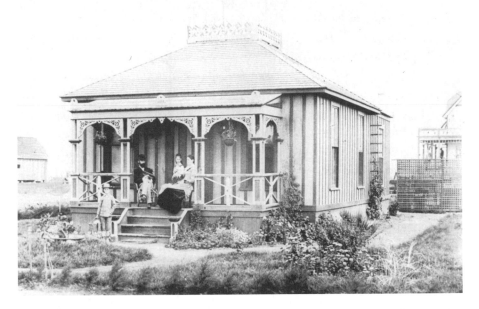

Your typical Long Beach family relaxing on the porch of your typical Long Beach home in 1888, the year of the city's incorporation.

will have to be repeated. The man who will beat up his wife should be given a tip into deep water. Long Beach has a reputation for decency and morality that should be rigidly maintained.

- *A little by-play that has been going on for a long time between a married man and a young lady is attracting attention and unfavorable comment. Better stop it before both reputations are ruined.*
- *Mr. Walter S. Bailey this week completed an enumeration of the school youth in Long Beach school district, including Alamitos and Signal Hill, showing the number to be 451, a gain of 39 over last year, which entitles the district to one more teacher, there now being six.*
- *The suit of Mrs. Rosa J. Butler vs. Frank G. Butler, for divorce, possession of property and alimony, came to a conclusion on Tuesday when the court gave judgment as prayed for. Long Beach people are tolerably familiar with the unpleasantness that had its inception two or more years ago, when Butler became "sporty" in his tendencies, after a wedded life of 18 years, and found the companionship of a Mrs. McKeon preferable to that of his wife. Because she would not*

agree to sue for divorce, Butler drove her from home and was himself thumped by Mr. McKeon in Los Angeles when caught on the street by the angered husband.

- *George Kimble has gone into business with a full-fledged tamale wagon, located at the corner of First and Pine, every evening.*

- *Some years ago, Jimmie O'Brien was in good circumstances, having made money in mining. He afterward in San Francisco deposited $4,500 in a bank to the credit of a Catholic bishop, who is to have him prayed out of purgatory. He has occasionally done some manual labor, sometimes gone a-fishing and along with it all managed to consume his share of booze. He cannot buy liquor here, but gets others to do so, and they share in its use.*

- *Complaint is made of a "cow nuisance" in the west end of town. Also, that horses are being turned loose and amble through the park where they find good feed.*

- *Will the person who borrowed a step-ladder from our premises please return the same?*

- *Wonder how many in Long Beach know that a regular poker joint is being run in our midst, and that young men are taking their first lessons in gambling? There are older ones, too, whose time and money were better spent in and on the home circle. There is plenty of legitimate amusement that is more honorable and less harmful.*

- *W.J. Clute, a young man from Redlands, has charge of the soda fountain at Wingard's. He's good looking, girls.*

- *On Sunday, John Orr, a youth whose years and connections would have given him better manners, indulged in language not found in Sunday school literature, while on the street, with reference to some ladies. Officer Baker gathered him in and the judge gave him five dollars' worth of advice.*

OLD IRONSIDES' SHAKEDOWN CRUISE

It was March 10, 1933—but don't panic: the earth still stood relatively still in Long Beach.

The big news—really huge news, commandeering the entire front page of the paper on the morning of the day of the Long Beach

earthquake—was the fact that the U.S. frigate *Constitution*, aka Old Ironsides, had sailed in for a ten-day stay at Berth 48, Pier 1, of Long Beach's Inner Harbor.

Authorized by Congress in 1794 and launched while Washington was president, the historic ship sailed (or, more properly, was towed by a minesweeper) on March 8 from Santa Monica, as thousands watched from viewpoints above Lunada Bay, Whites Point and Fort MacArthur on the Palos Verdes Peninsula. An armada of more modern craft, including the USS *California*, the USS *Tennessee* and the giant aircraft carrier USS *Lexington*, accompanied the magnificent frigate.

On the tenth, several hundred schoolchildren visited the *Constitution*; virtually all had donated pennies toward the ship's refurbishment in 1931, as had thousands of students and organizations nationwide.

Charles Francis Adams, who was secretary of the navy during the ship's repair, said in a speech that, because of these donations, "the most famous warship of our nation may be said to belong to every person in the United States of America" and urged everyone in the country to visit their ship.

And while not everyone did visit, they nevertheless came in impressive numbers. The refurbished *Constitution* was in Long Beach as part of a massive tour in which it visited some ninety seaports and was boarded by more than 5 million people. Prior to coming to Long Beach, about 466,000 people checked out Old Ironsides in Santa Monica, and according to the March 10, 1933 *Long Beach Sun*, "It is estimated that fully 300,000 persons will inspect Old Ironsides while she is the guest of Long Beach, provided the weather man provides the proper weather."

The weatherman did his job just fine. It was the seismologist who dropped the ball big time. Shortly before 6:00 p.m. on the tenth, Long Beach was struck by the historic quake. The grandeur of Old Ironsides was completely obliterated by the tragedy and destruction of the quake. The local tour was canceled, and the ship left town, barely noticed, to continue the rest of its tour.

The ship returned, however, to a still shaky but nevertheless enthusiastic Long Beach for a two-week stay in October 1933.

THE LONG BEACH EARTHQUAKE

On March 9, 1933, Long Beach was about as happy a city as you could find in the atlas.

Its booming, good-time downtown area was crowded with shoppers and sightseers. When there was a cause to celebrate, Pine Avenue would overflow with a joyful, noisy crowd, with many traveling in from the north part of town via Red Car.

The city's slogan was "California's Metropolitan City By the Sea," and tourists came to the strand that in those days outsparkled today's Newport and Redondo Beaches. There wasn't a kid who didn't want to go to the Pike with a pocketful of pennies and nickels.

Long Beach was a growing town but still small in 1933. The population was about 157,500, and it was a mere 29.65 square miles, compared with today's 50.00.

Its agricultural east side hadn't been colonized. The roads that would become Lakewood and Bellflower Boulevards were long, boring stretches of road that ran through sugar beet fields and dairy farms. Residential growth halted seven blocks east of Recreation Park. On the north side of town, houses only went as far east as Cherry Avenue. As you drove down Wardlow Road, you'd cross Gaviota, Rose, Gardenia and Cherry. After that, there was Daugherty Field—later to grow into Long Beach Airport—and then nothing but acres and miles of farmland.

Of the 435 miles of road in Long Beach, only 192 miles were paved.

There were thirteen banks in the city, almost all of them downtown.

On March 9, 1933, there were five hospitals with 492 beds. Barring disaster, that seemed adequate.

Fifty years ago, the city's twenty-eight schools seemed solid, some even appeared intrepid when you looked at them. There was Jefferson Junior High, with its towering brick façade; there was Poly High, with its majestic dome.

Culture came to the Ebell Theater or the Municipal Auditorium. The Community Playhouse players entertained the city with live theater. Currently playing: *Little Women*.

The Long Beach Municipal Band played regularly in the city's parks. Later in the month, the band would give its most stirring performance,

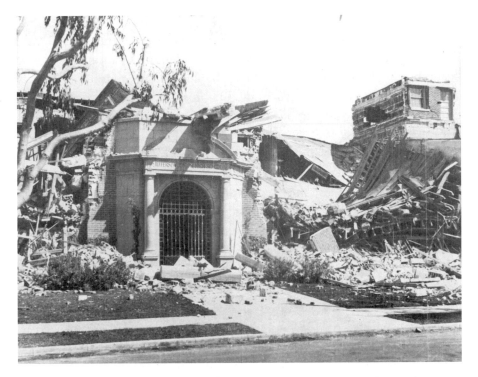

A Community Playhouse production at Jefferson Junior High School had wrapped up less than an hour before the quake destroyed the school.

bringing tears to a crowd of more than fifteen thousand people—survivors—and there would be no applause.

At 6:00 p.m. on March 9, 1933, life went on: Cecil Adrien, thirty-three, and Howard T. Kennedy, thirty-nine, sorted mail at the Main Post Office downtown.

Tony Gugliermo, sixteen, jogged home from a track workout at San Pedro High, preparing for a meet the next day in Long Beach.

James Brodie, the twenty-nine-year-old manager of the Imperial Theater, worked in his office, pleased that the movie business was booming.

Jarvis Davis, thirty-five-year-old state motorcycle officer, was finishing dinner and preparing to start his shift.

Three-year-old Delores Marie Mitchell played in the front room of her parents' home on Anaheim Street.

Helen Mitchell, eighteen, was preparing dinner for her husband.

They were surrounded by the trappings of the era: portraits of a heroic FDR clipped from copies of the *Atlantic*; the scent of steaming fruits and vegetables that could grow in the Long Beach climate; mammoth Buicks and Oldsmobiles lining the curbside. Oak iceboxes holding glass jugs of milk and cream. A radio as big as a chest of drawers playing a brass band concert through the haze of static.

Pies on the windowsill, dogs in the yard, hats on every head.

If you went out after dinner on the night of March 9, 1933, you could feel the sultriness of the air—too stuffy for the end of winter. Then, if you looked up in the sky, you would see a pale halo around the moon.

If left different impressions on the people who saw it. They couldn't tell you if that halo seemed glorious or ominous.

In the minutes before the quake on the evening of March 10, 1933, the city was in a quiet mood, wrapping up the day, getting ready for supper, making last-minute visits to the corner grocer, corralling their children in from play.

In their living rooms, they had their radios tuned to **KGER** or **KFOX**, where reporters and editors were preparing for the 6:00 p.m. broadcasts, which were to top with news of President Roosevelt's declaration of a six-day bank holiday, an effort to turn around the depressed economy.

At the city's two daily newspapers, the *Press-Telegram* and the *Sun*, it was a slow news day. Some workers had been sent home early.

The Community Playhouse performance of *Little Women* at Jefferson Junior High finished at 5:00 p.m., and the children were all out of the auditorium by 5:15 p.m., with plenty of time to make it home before dark.

The darkness came earlier than expected. Mothers and wives who were cooking dinner suddenly saw the food begin to move in front of them. Canned preserves and hand-painted china flew from ledges and cupboards. Children playing on the living room rug looked up with curious expressions at their fathers sitting in easy chairs. Outdoors, people lost their footing; cars ignored their drivers' commands.

Time was measured in slow tenths of seconds with the initial feeling of curiosity, turning to dread and then fear and panic following the first impact at 5:54:08 p.m. After that, the world began to end.

And it was just as you might imagine: women and men fell to their knees and prayed. There were tears, screams, sobs, all lost in the wrenching sound of a planet tearing apart.

The initial, strongest jolt of the 6.3-magnitude Long Beach earthquake lasted for eleven seconds—the greatest part of eternity for virtually everyone in a town that had grown satisfied, even smug, with the feeling that it was the perfect place to live by almost every measure.

During part of those eleven seconds, Frederick Borum Cole, sixty-one, felt the earth heave and lurch. With him was his young granddaughter. There was no question as to what he should do. Instinctively, Cole wrapped the girl in his arms, shielding her from the collapsing building. He died holding his granddaughter beneath the rubble of a poorly built building on Fourth Street. His granddaughter survived.

During those same eleven seconds, nine blocks to the north, Dolores Marie Mitchell had no grandfather nearby to protect her. The three-year-old girl was found crushed to death on the stairway in her house on Anaheim Street.

On Ocean Boulevard, Vera Rogers and her husband were in a poultry shop when the earthquake made them feel as though the world was ending. In a panic characteristic of most of the people in a city falling apart, Mrs. Rogers fled when the quake hit.

Then, overpowered by an even greater urge, she remembered her husband still inside the shop as the bricks and debris rained along the boulevard. She ran back inside to look for her husband. Together at last, the middle-aged couple once again fled for the imagined safety of outdoors.

The building above the couple performed one or two steps of its surreal dance and then crumbled and fell on the man and his wife. They both died on the sidewalk along the boulevard.

At 5:54 p.m., James Brodie, the assistant manager of the Imperial Theater, was in his office, waiting for the movie to end. Seconds later, he was on the stage in front of the movie screen, pleading with the audience to remain calm and to please exit slowly. Everyone in the theater proceeded with caution, calmed by Brodie's even tone. Brodie was the last to leave after seeing everyone off safely. He was struck, then, by a falling canopy and killed.

Tony Gugliermo, a sixteen-year-old student from San Pedro High School, was toweling off after a shower in the locker room at Wilson High after a track meet. The quake didn't damage Wilson as much as it had other schools in town, but the locker room roof collapsed, killing Gugliermo and injuring several other athletes.

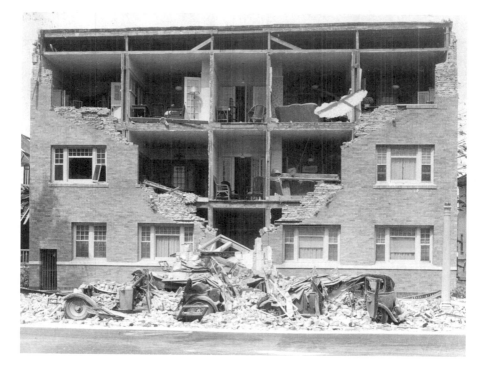

All up and down the city's streets, entire fronts of buildings, merely bricks stacked atop one another, fell to the ground.

There was nowhere to hide. While Helen Mitchell, eighteen, was killed by a falling canopy on Anaheim Street as her helpless husband watched in horror, and while Pauline Sanders, thirty-two, was killed the same way on Pine Avenue and Eighth Street, Cornelia Chittenden died inside her home on Gardenia, and Dina Onsum was killed in her Ximeno Avenue home when the walls of their houses collapsed.

Fifty-one people died in Long Beach in the quake.

The brick walls that made up too many of the city's buildings came down like a kid's building-block castle kicked to pieces by a bully. Wooden beams and flooring rammed the cheap mortar walls that couldn't contain them when, as the buildings swayed, they acted as battering rams.

And if the initial eleven-second jolt didn't cause a building to fall, one of the aftershocks might've done the job. They struck at 6:06, 6:10, 6:12, 6:15 p.m.—thirty-four of them by midnight.

The quake destroyed 1,831 homes and damaged 21,000. All the schools suffered considerable damage, as did most of the city's churches.

The Columns

The dome at Poly High collapsed into the main hallway. Jefferson Junior High totally collapsed and burst into flames. The marble altar crumbled at St. Anthony's Catholic Church when the ceiling caved in. All up and down the city's streets, entire fronts of buildings, merely bricks stacked one atop the other, fell to the ground.

Overhangs and balconies had been stripped from houses; pillars meant to support front porches were knocked away, allowing the roof to collapse. The entire northwest corner of the Ebell Club had been knocked away as if by a bomb. The Bank of America and Post Office branch on Seventh Street and Redondo Avenue had almost completely collapsed. A bakery at Anaheim and Redondo looked like a multitiered wedding cake that had been shoved off a high shelf.

Fires erupted in several spots in the city, and although the main fire station had been destroyed by the quake, the fire department was able to hold the damage to a minimum. In the days following the quake, the department would be headquartered in a tent adjacent to the pile of rubble that had its station downtown.

Streets were clogged with the debris from the buildings. Telephone poles had swayed and snapped, knocking the city's 32,052 phones out of service. There was no electricity, and fortunately, an alert gas company employee had turned off the gas lines serving the city.

Cars were buried beneath the collapsed sides of buildings. The great outdoors was not the place to be.

Rumors were rampant: San Pedro's Point Fermin, word had it, had tumbled into the sea. Santa Catalina Island, too, was gone, disappeared into the roiling Pacific. The biggest news of all was of an approaching tidal wave.

The rumor split the city in two, with half the citizenry rushing to Bluff Park to watch the wave and half heading up Signal Hill to escape it.

Few people slept that night. Few people went back into their shaky homes. Few people knew what they were supposed to do.

The fog rolled in over the crippled city. People trying to sleep beneath the trees at Bixby, Lincoln and Recreation Parks or in their own backyards were distracted from the condensation falling from the leaves.

The people of Long Beach had not believed such a disaster could visit their city. Now they lay awake wondering how disastrous the day had been, and while the aftershocks continued to roll through the ground beneath them, they wondered if the worst was still to come.

The days following the quake were days of healing, regathering, reconstruction.

While the rebuilding of the schools began almost immediately, the school district bought tents with floors, wallboard sides and canvas tops for temporary schoolrooms.

Poly and Wilson High Schools met in the bleachers and on the grass at Recreation Park. Most of the Main Post Office was moved outside on Seventh Street near American Avenue. Fire Station 1 moved to a tent between Pacific and Cedar Avenues on Broadway. Several churches conducted their services in parks and in tents near their buildings.

There was an outdoor barbershop and several outdoor markets, and book-laden trucks from the Long Beach Library brought reading material to the people camping in Lincoln Park.

There were several classes of people in the camps maintained by the Red Cross. Most of the people were actual victims of the disaster who lost

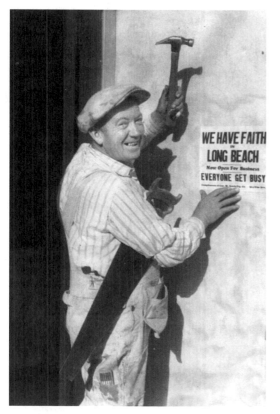

Rebuilding Long Beach was a massive undertaking, providing jobs for workers of almost every sort to repair the $50 million in damage done to Long Beach.

their houses, but there were also county cases driven from their shelters, as well as others who were homeless and penniless to begin with.

Two weeks after the quake, most of the city's buildings and residences had been inspected and were released for occupancy if they were found safe.

The crippled buildings provided jobs for workers of almost every sort to repair the estimated $50 million in damage.

Congress made $5 million available in the form of low-interest loans to earthquake sufferers through the Reconstruction Finance Corporation, and voluntary contributions came from all over the United States, as well as from China, Japan, England and Italy.

At 2:00 p.m. on March 26, 1933, fifteen thousand people gathered in Bixby Park for memorial services for the fifty-one Long Beach citizens who died in the earthquake. No one applauded during the somber requiem as the Long Beach Municipal Band, directed by Herbert L. Clarke, performed "Onward, Christian Soldiers," "One Fleeting Hour" and, from Dvorak's New World Symphony, "Going Home."

Letters from Shakytown

News traveled seventy-five years ago, but it didn't travel fast.

After Long Beach and surrounding cities were rocked and devastated by an earthquake on the evening of March 10, 1933, information (and misinformation) zipped across the affected towns by word of mouth and on the radio airwaves—most notably Long Beach's KFOX. And the newspapers got the word out as quickly as the intrepid reporters could type it up and the presses could shoot out the urgent editions.

But the folks back home in the Midwest, most famously in Iowa, which had supplied so many residents of Long Beach during the city's early years, waited anxiously for days and weeks for mail to arrive from the survivors telling about the excitement and terror of the earthquake.

Telegraph offices were packed, and telegrams were terse at best. More elaborate news came in the weeks following the quake, and local papers in the Hawkeye State printed up these colorful missives to get the word out to readers who were insatiable in their desire for more news from their friends, relatives and former neighbors on the shaky West Coast.

Sometimes, the editors couldn't mask their smugness about the horrors of California. "It is going to take a lot of 'climate' to make people forget the destruction of life and property that has been wrought by those shocks," wrote one paper boss. But generally, the writers' words stood alone and sufficient.

Following are a few snippets from those who experienced the Long Beach earthquake:

From Mrs. Ira Deal, Long Beach (printed in the *Oelwein Daily Register*, March 17, 1933)

My first and only thought was to get in the middle of the street so I started, but it threw me almost off my feet, twisted me in all shapes, slapped the bottoms of my feet until they tingled for a long time...People were running, sirens screeching, women screaming and the roaring of the earthquake like terrible booming, tumbling thunder. O, it is so horrible and terrorizing to even think about it yet!

The Western Union office, shown here, and the post office were open for business outdoors in the days following the earthquake, enabling Long Beach residents to send news back home to worried relatives.

The Columns

From William H.H. Roth, Long Beach (printed in the *Waterloo Sunday Courier*, March 19, 1933):

> *Outside, a brick landed squarely on my head, knocking me to the pavement in a daze. Many others were either writhing in pain on the sidewalk or were just lying there still.*

From Effie Walker, Long Beach (printed in the *Adams County Free Press*, March 23, 1933):

> *At first I thought my husband had been killed by falling debris. Just as I reached the sidewalk, a man was being carried from an adjoining building. About that time, my husband appeared on the scene from our apartment and rushed us to the middle of the street.*

From P.L. Schoep, Glendale (printed in the *Sioux Center News*, March 23, 1933):

> *It is a sensational experience to be in an earthquake. It all happens in the twinkling of an eye. A thundering noise with the shaking of the earth. It feels just like you are walking in a small rowboat on the water.*

From Maude Winter (printed in the *Lake Park News*, March 23, 1933):

> *My dad was leaning close to the medicine cupboard mirror lathering his face. The door sprung open and smacked him in the nose. All the little medicine bottles from inside fell in the sink. As soon as he could hit the door he came dashing out looking like a mad dog with lather all over his chin.*

From Mr. and Mrs. C.H. Munson, Arcadia (printed in the *Milford Mail*, March 16, 1933):

> *Most everyone is out in their yards cooking on bonfires. Saw lots of chimneys down and plate glass windows broken. They won't let you drive through town. Long Beach is fierce, I hear. Guess we can all be thankful we are here and alive. I sure hope we don't get any more today. It was sure an awful feeling, but I guess they're not so bad as cyclones.*

From W.W. Little, Long Beach (printed in the *La Porte City Progress Review*, March 23, 1933):

> *We did not sleep in the house* [on the evening of the quake] *but stayed out in the car all night. There are about 2,000 people living in tents in Recreation Park and there are more than that camping in Bixby Park. Well, this is all for now, hope to hear from you soon.*

About the Author

Tim Grobaty, a Long Beach native and resident, has been a reporter and columnist for the *Long Beach Press-Telegram* for more than thirty years. He has won numerous awards, including Best Columnist in the Western States in the Best in the West journalism competition in 2009. He is a recipient of the Long Beach Heritage Award for his columns about the city's history, and he is an inductee in the Long Beach City College Hall of Fame. He lives in Long Beach with his wife, Jane, and children, Raymond and Hannah.

Photo by Brittany Murray.

Visit us at
www.historypress.net Storm